Family History Memory

HYLAS

First published in 2005 by Hylas Publishing
129 Main Street, Irvington, New York, 10533

Publisher: Sean Moore
Creative Director: Karen Prince
Designer: Gus Yoo
Editorial Director: Lori Baird
Editor: Gail Greiner

First American Edition published in 2005
02 03 04 05 10 9 8 7 6 5 4 3 2 1

ISBN: 1-59258-086-6

Set in Garamond and Franklin Gothic

Printed and bound in Italy by Milanostampa/AGG
Distributed by National Book Network

www.hylaspublishing.com

Family History Memory

Recording African American Life

Deborah Willis

This book is dedicated to the memory of my dad, Thomas Meredith Willis and nephew, Songha Thomas Willis. To my son Hank, grand-nephew Masani, my teachers; students, past and present, whether in the classroom or living room, workshop or coffeeshop. Thanks for continuing to inspire me.

—Dr. Deb

Family History Memory

I love myself when I am laughing.
And then again when I am looking mean and impressive.

—Zora Neale Hurston

Foreword

Deborah Willis' earliest photographs, taken when she was around nine years old, were of her family's Christmas presents and their television set—not universal images but rather pictures of a particular moment in the life of an African American family alive at a particular moment in American culture.

An accomplished archivist, curator, professor and, of course, photographer, Willis has imbued all of her work with this kind of historical and cultural awareness, assembling in black-and-white and color photographs, photo-quilts, and fabric collages, a history of images and visions of African American life. For almost as long as photography has existed as experiment, art, or household commonplace, it has captured the moments created, witnessed, and lived by African Americans.

If I had to choose a favorite among Willis' multitude of images, I think it would have to be the photo of her nephew, Songha, at about age nine, doing a jigsaw puzzle at the family dining table. There are signs everywhere of the life they lived at that table, in that house, at that particular moment: the open glass bottle (of soda?) that props up the puzzle box lid; the picture on the box of the "Peanuts" gang boarding a London double-decker bus; a piece of clothing tossed onto the table; Christmas cards taped to the room's

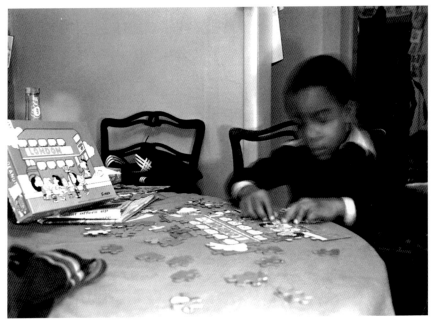

Untitled {Songha with puzzle}, c. 1978

open doorway. Some details are indistinct—I cannot tell what the piece of clothing is, and even Songha is a bit of a blur, but I immediately recognize the beautifully humane rhythm of the scene.

True, I was once a nine year-old boy doing jigsaw puzzles at our dining table, but I was not that boy at that table doing that puzzle. Willis' gift is to bring us into each picture, inviting us to remember our own family and our own history, and making us see that to do so is the best way to understand another's.

—Henry Louis Gates, Jr.
Director, W. E. B. Du Bois Institute for African and African American Research, Harvard University

Author's Note

This is a collection of my photo quilts, photographs, and a number of my essays that have been published previously in edited volumes, exhibition catalogs, and monographs. I have published a number of books on the photography of others: This is the first time my own photography is being published as a collection. I spent the last 30 years researching, compiling notes, writing about photography and its impact on our culture, and making pictures of my own.

I worked closely with my son, Hank Willis Thomas selecting images for this book. In reviewing my negatives, contact sheets, and prints, Hank was amazed at the range of images I had made over the years that were never published. He was also dismayed that I rarely discussed my work as a photographer or included my photographs in exhibitions. I felt I was primarily a curator and writer, so I had shied away from promoting my own photography.

As we began to select and edit, however, I found an interesting correlation between my writings and my photography. Hence, the book's title: *Family History Memory*.

With this book, I hope to engage the viewer by exploring the choices I have made in my life as a photographer, historian, mother, and mentor. It shows my

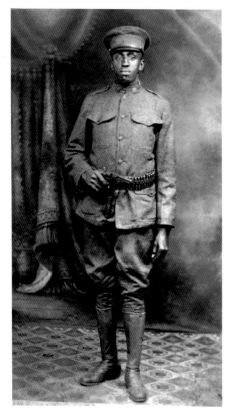

Herbert Willis, World War I, Soldier

transformation as a student of photography to one who asks questions about the black image in photographic history.

My experience with photography has many dimensions. I attempt to relive family memories by incorporating old photographs from the "collective archive" of black culture into contemporary images exploring the nuances of memory. I often print photographic images on fabric. In photographing my own family, I found a way of entering the past and commenting on societal issues that I believe helped to shape my interest in visual storytelling.

Studying photographs has inspired me to reflect on my own family pictures and to place them into my artwork. I am especially intrigued by these photographs from my own family album.

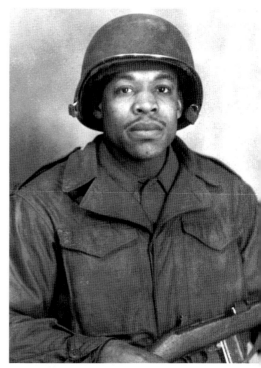

My father, Thomas M. Willis, in WW II uniform

The first is of my great uncle. My paternal grandfather's brother, who fought in France in World War I, posed for a photographer in Virginia upon his return from war. He is in full uniform and holds a pistol. The studio is draped in the fashion of the period. The pattern on the rug is a bit distracting. My great uncle's gaze speaks of loneliness but the uniform tells us of a bond with other men. His eyes are my eyes. Large and silent.

My father sent his own portrait home to my mother, his new bride. His pose is full of hope and pride. His adventure of leaving home to join the war and travel around the world was a story told throughout my

13

childhood. He is holding a real rifle and is also in full dress. My father in combat helmet, looking directly into the camera, appears to be sending home a message. Could the message be that he is finally preparing for war? As with all black soldiers in World War II, he was given only a wooden rifle to practice with; the government did not give black men real rifles and ammunition in war game simulations. He signs the photograph, printed on a post card made in Germany, "your hubby."

My mother sent him a photo of herself as well. She is standing in a photographer's studio, smiling and sending a silent message to him. Probably, "Come home safe."

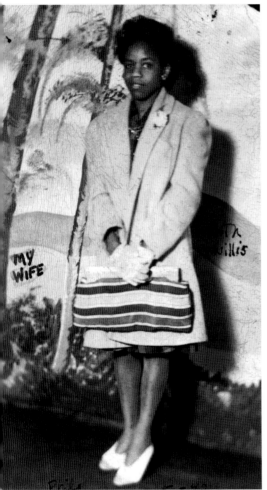

I am still interpreting silent messages in my writing and in my photography. My art has always focused on photography as biography, as a way of documenting the female story. Ultimately, I see and use photographs as evidence of life experiences.

My mother, Ruth Willis

14

Introduction

Born in Philadelphia, Deborah Willis developed her early interest in photography from her father, an amateur photographer who took the family photographs, and his cousin, the proprietor of a commercial studio. Family, history, and memory are important recurring themes in her visual work. She has consistently turned her uncompromising eye on explorations of these themes. "When I grew up in North Philadelphia, the camera was a central element in our lives. My family treasured their past—as evidenced in their ability to tell stories and preserve objects, clothing, and photographs. Studying photographs as an adult has inspired me to reflect on my own family pictures, and to place them in my own artwork."

Willis received her first camera one Christmas around 1957 and she made photographs of the carefully wrapped gifts under the family Christmas tree and of the family's television set, the first in their North Philadelphia neighborhood. "Members of my family would visit on weekends and evenings to sit and watch. One great-aunt, Cora, brought along her blind husband and her unfinished quilts. She often pieced together beautifully colored and geometrically shaped quilts while watching television, explaining events to her husband between stitches."

These first photographs Willis made with her new camera were later used in *Date Unknown*, 1994, one of her narrative quilts that also incorporated a yo-yo pattern quilt piece Cora gave her. The work also positions the literal and metaphoric centrality of the television in the American home and lifestyle. "I photograph and use my own family photographs and archival references to incorporate stories and social politics into my art, hoping to invite a larger public to imagine these experiences—both collective and individual—of African Americans in the 19th, 20th and 21st centuries," she explains. "Autobiography is essential to my work."

My Professor Anne Wilkes Tucker in the Cafeteria, PCA, 1974, Paul McGuirk

STORYTELLER, SPECTATOR, ARTIST

Willis began her formal study of photography in the mid-1970s as a student at Philadelphia College of Art in Pennsylvania, where she studied with photographer Ray Metzker and historian Anne Tucker. Roy DeCarava, Duane Michals, Brassaï, Moneta Sleet, Jr., and Helen Levitt were her early influences. She also made figure studies à la Edward Weston, enlisting friends and colleagues to pose. She later received her Master of Fine Arts degree from Pratt Institute in Brooklyn (1980) and a Ph.D. in Cultural Studies from George Mason University (2003). In the 1980s, her work focused on street scenes in a documentary style.

While teaching photography, she continued to photograph her family, particularly the young children including her nephew and her son. "My work with children began...in the early sixties, and as a mother I often used the time spent photographing my own child and my nieces and nephew to imagine their lives in the 1970s and the concerns of child play," she explains. "As I explored their world, I thought about the experiences I had had as a child in a segregated society, ones that they

16

do not have to experience today."

There was never a question of figuring out how to incorporate art practice, work, and single-parenting, nor was it a surprise when her son followed in her footsteps: "Hank spent a lot of time, most of his life, in galleries helping me install shows or, when he was little, just watching me and having to stay at work late with me to make sure everything was up, and then at the openings. And so he said to me, 'Well, Mom, did I really have a choice?'"

Willis has been called a "visual griot," (storyteller) and indeed, the stories she tells are of African American lives and histories. For Willis, the structure of biography, of collective and individual memories, informs her exploration of the cultural values and traditions in the black community, linking the past and the present through art making. It is impossible to separate the themes that run through her work—women: their unsung lives, their uncredited labor; beauty; and life, illness and death, all of it stemming from her own family and their stories and experiences. Each project builds not only upon the historical past, but also upon each previous body of work; her work evolves in a cycle of lifelong thought processes and investigations. She works in a narrative mode, describing her work as a storyteller might weave a tale, and the metaphorical language is no coincidence. She "weaves" visual and verbal language to construct a "fabric" of knowledge and understanding.

"FABRIC-ATED" HISTORIES

She pieces together imagery, patterned cloth, trinkets, and bits of trim, to salvage lost lives and turn remnants and ruminations into related narratives.

—Trudy Wilner Stack

Willis' father's death in 1990 prompted her "to revisit my photographs of family members, as well as photographs from our family album. I found myself searching through his trunk of photographs and

negatives in an attempt to preserve his memory." During an artist's residency shortly thereafter, Willis began a series of photo quilts that incorporated the textile traditions of her grandmother and great-aunt, and referenced her father's profession as a tailor, often using vintage fabrics including his old neckties. *Daddy's Ties* (1993) was based on three family photographs. One was of her great-uncle, who posed in full military uniform for a studio photographer in Virginia after returning from World War I. The other two are of her parents—a photo postcard from Germany that her father sent to his new bride of himself in full military uniform signed "your hubby," and the studio portrait she sent back to him of herself as an independent, stylish, smiling, working woman.

Of her father's work, she wrote, "I was struck by the range of photographs he produced and tucked away. I looked at the photographs of the men and women—laughing, playing cards, and posing in the studio." During her residency, she printed more than 100 images of family on photo linen and paper. The resulting artworks are both quilts and fabric collages, equal parts folklore and history lesson, with image, textile, and meaning layered one upon the other, non-linear and intersecting, generating new narratives of universal experience:

"I found the quilt-making process much more expressive in making my art. I wanted to tell stories visually and to somehow incorporate historical references into my photography. I used the quilting tradition to create my artwork because historically those in my family have always been quilters and storytellers."

"Willis' numerous textile works cannot be categorized in any one style. They range in influence from quilt patterns associated with white colonial New England to African textile designs," wrote Alison Ferris, curator of the 1998 exhibition *Memorable Histories and Historic Memories*. "This wide variety of patterns and designs, combined with the inclusion of photographs, printed on photolinen, secures the textiles in social, political, and economic circumstances." The images Willis' father took were more than family memories; they were social and community histo-

ries viewed through a personal lens, and Willis was struck by how similarly she and her father had treated their subjects over the years.

She ultimately focused on images of the women in her family and their friends. "I thought about creating art about these beloved family members, and the women they knew who cleaned, ironed, and prepared food for people other than their own families." Quilts made about such women include the poignant *No Man of Her Own*, 1992-94, a tribute to her beloved Aunt Annie, a washerwoman, exhibited with an old straw suitcase with a worn pair of shoes that had belonged to "My Sweet," as Willis called her. "I was required to finish the ironing before I was allowed to go to a Saturday matinee. The women in my extended family shared weekly chores, gossiping the time away in my mother's beauty shop, sometimes about my aunts and cousins who were washerwomen."

Though family is Willis' métier, she also addresses women's collective histories. Photographs she made in August 1988 at the Sisters of the Boa Morte festival in Brazil resonated with her because of the women's history being told through these subjects, women of an African Brazilian group who meet annually to celebrate their ancestors from the city of Cachirea who survived slavery. Willis incorporated eight photographs of young girls living in Bahia into the quilt *Brazilian Festival: Sisters of the Boa Morte*, (1992), paying homage to their struggles and honoring their legacy. "The sisters started out as women who were freed and had no families to go back to," explains Willis. "They banded together."

REGARDING BEAUTY

How do women define beauty? African American women have our own traditions and rituals. It is often at the beauty shop, a woman-only space where all our collective stories are told and retold. It is a safe place of history and memory where some women will tell all their business, and others cannot keep their secrets. In photographs made in these most intimate public spaces throughout the South and in the Northeast, Willis captures whole lifetimes in a single frame.

For Willis, examining these rituals of beauty is not new. She began to address it in the *Virginia Back Roads* series from 1993, undertaken with material support from the Polaroid corporation. The images show window displays of forlorn black and white mannequin heads, of barber shops with hand-painted signs, of "the different cultural icons that make strong visual statements within our own cities," wrote Willis.

Her 1994 quilt *Doin' Hair*, which includes images of pressing combs, hair oil, and pomades, is "a testament to her mother's entrepreneurial drive and, in a larger context, a rite familiar to most African American women and men." Recent photographs Willis made of young women of the hip-hop generation in South Beach, Miami (2004), displaying more public body confidence than their mothers ever dreamed of, are an up-to-date reality check. They are the legacy of this cultural support system of self-love and beautification.

Willis explores the definition of beauty:

> *My mother is in her late 70s and the women that she attended Beauty Culture School with in the 1950s are still working. They're still doing hair, and manicures and pedicures, and still using that aspect of female beauty in their work. These are older women who are working and who continue to go to the beauty shop. It's this communal experience that I am interested in documenting. I'm looking at this whole aspect of how beauty is defined, how community is defined, how women share moments together.*

Not even her own personal difficulties with breast cancer escape the focus of her camera. Never before given to self-portraiture, she photographed herself getting a manicure. While inches away from the nail file, chemo drips slowly into her hand, the vanity of the act belying the simultaneous slow poisoning—and healing—of her body. In a stark, gorgeous portrait after losing her hair to chemotherapy treatments (*Bald 3 Days*, 2001) in which an out-of-focus background sculpture hovers behind her like a hairpiece that has taken flight, she responds to this

physical transformation and to the varied and often puzzling responses to baldness and cancer she received from friends and strangers.

BODY BUILDERS

When these photographs were shown in Madison, Wisconsin, in 2003, they sparked outrage. Willis says:

> *A lot of women who come into this building are thin, blond, and 19. Some think the pictures reflect a bias against women, or they want to know why a woman would do this to herself. Or {they think} that bodybuilding isn't about beauty, it's about narcissism.*

Willis' close-up portraits of bodybuilder Nancy Lewis, ranked ninth in the world, invite reevaluations of beauty, gender, and musculature. "During the shoot, we talked for a bit about how she perceived herself. She said she sees her body as beautiful, and her entire body as feminine with strength." In one view, she focuses on Lewis' sculptural buttocks and thighs. Her outstretched hand, so delicately poised and tipped with pointed nails, subverts the viewer's instinctual understanding of the body and its ornamentation. A view of Lewis' back defies gender categorization; only the strings of her performance costume suggest that the subject might not be what she appears at first glance. Willis renders Lewis' body without sensationalism, forcing the viewer to re-examine his or her definition of beauty and strength in the black female body. Lewis' construction of her body is a form of self-portraiture that rewrites the definitions of femininity and sexual appeal.

Relating the unlikely subject of body builders to her earlier work around domestic workers, Willis pairs the image of a tightly muscled stomach (*Washboard Stomach 2*, 1998) with photographs of an actual old washboard (*Washboard I* and *Washboard III*, 1999).

When I tie in the washboard, I think about women who had to maintain their strength as washerwomen and used that experience maintaining their families, raising families and being the breadwinner. And some of these women are the same—they are the breadwinners of their families, because a lot of these people are from working-class, blue-collar families. And so {body-building is} an area where they can find a place to negotiate their sense of pride and strength.

THE ARCHITECTURE OF PLACE

In 2003, in Eatonville, Florida, folklorist Zora Neale Hurston's home-town, Willis went "looking for the singular portrait of Eatonville," but "found a collective portrait that depicts a town." There, influenced by Hurston's own words about the place, she photographed in restaurants, beauty shops, and churches, bringing a living history forward to its present reality.

She also photographed the "shotgun houses"—one room wide; three, maybe four rooms deep—so-called because of the ability to fire a bullet through the front door and have it exit out the back without penetrating anything. Initially, these were narrow, one-story wooden-frame houses built inexpensively for free blacks and immigrants—the working class. In these house "portraits," the buildings come alive in rich, textural color overlaid with vivid narratives, and glimpses into lives lived and struggles over-come. "We were pushed out of our homes and cried, but we found beau-ty in what we made," reads the text superimposed on one image (made in South Africa) of tiny, patched cobalt blue structures in a dirt-scratch yard (*Untitled*, from the *Shotgun* series, 2002-3). Another reads: "She ironed shirts in the living room/ and in the bedroom she taught herself/ how to read. 1954 was a crucial time in/ her community. She wanted her children/ to have the same education the white/ children had, the chil-dren that she washed/ and ironed for on a daily basis." This could describe any of the women whose lives Willis has celebrated through her work (*Untitled*, from the *Shotgun* series, 2002-3).

"Gloria was known for her catfish at the juke joint," while "Mary used to bake peach cobbler every Saturday." Willis narrates speculatively, locating the significance of food in culture heritage and experience. Fiction and personal history intersect; her own maternal great-grandmother, Mom (Catherine) Foreman, made peach pies "and sent her children and grandchildren out to sell pies for five cents at the subway stop at Broad Street and Columbia Avenue in North Philadelphia." Willis remembers hearing the stories passed down through generations. "They sold pies on Friday and Saturday nights and families often told them that the pies were served on Sunday for dessert. The left-over peach skins and peaches were used to make peach wine which was served during the winter holidays."

DEATH AND LIFE

My work is based on social concerns...as well as political issues that address the oppressed....Political and racial issues facing this society, the Middle East, and Africa have been a primary interest in my life.

Willis approaches her subjects as she would her own neighbors—respectful and empathetic, all too aware that what she has to offer by way of communion is her voice and her vision and her innate desire to always honor their lives, not her own. Even in war-torn Palestine, she finds moments of solitary peace.

Of the funeral images she has made, a centuries-old visual tradition in African American communities, Willis is matter-of-fact. "I attended so many funerals in my lifetime because of the size of my family and how I felt about loss. It's difficult to describe, but I found beauty in the closeness of the ritual." Willis feels these photographs are far from macabre, but are instead celebrations of life, inclusive of our entire journey. This reclamation, this dogged determination to recognize and validate individual lives and histories is what drives Willis' art, what makes it ultimately universal:

In constructing a photo story through memory, I situate my own family and the life of other African American families. By telling my story, I hope to make possible for my viewers to visually consider the shared experiences of black women workers, many who had or have their own cottage industries as laundresses, hair-care specialists/beauticians, day-care providers, and personal trainers.

Yet, despite all of the work she has produced, she refuses to single herself out, preferring instead to locate herself within a larger framework: "I explore the possibilities of these experiences and reinvest in black female agency as a way of locating an identity of the black female artists in history." As a visual artist well-versed in a multitude of histories, from the photographic to that of the black family, Willis is the consummate gatherer and interpreter of our collective lives.

—Carla Williams
writer, editor, photographer

Quilts

Pieces of Memory

In my artwork, I link the historical past with my personal history. In doing this, I become the storyteller, the spectator, and the artist. My training as an artist has inspired me to frame my work within cultural history and to examine the role memory plays in creating art.

In 1990, after my grandmother's death, I began to incorporate the quilting tradition into my art work, in part, because members of my family have always been quilters and storytellers. My maternal grandmother, Lillian Holman, had 13 children and recycled clothing, blankets, and other hand-me-downs until they were no longer recognizable in their original form. She would then make quilts of the salvageable items. My grandmother gave quilts to all of her children and some of her older grandchildren throughout her life. Gram, my name for her, died in 1990 when she was 88.

My paternal great-aunt Cora, was also a quilter, as well as a ceramist and canner. Visiting her as a child in the early 1950s, I marveled that she called herself an artist. Aunt Cora lived in Philadelphia from 1941 until the mid-1970s when she moved back to her birthplace in Orange County, Virginia, where she became known as the lady canner and quilter. She died in 1986.

My own quilting process includes recycling as well, but of photographs as well as fabric. I re-print old photographs on photo linen, a pre-sensitized photographic material. This enables me to sew photographs directly onto other fabrics, like silk, cotton, and satin.

After my father's death on Father's Day in 1990, I worked with my mother and sisters to make a quilt about his "image" from ties that we gave him as presents for Father's Day, Christmas, and birthdays throughout the years. It was an interesting way to hold onto our individual "ties" to him. I began to see his quilt as Egungun, a Yoruba deity that represents the ancestral community. That lively quilt, with its many colors and photographs, was a testament to our love and respect for him. The grieving process had just begun and would last for some eight years

as I continued to use his photographs to make autobiographical art.

Family photographs are my reference in which to construct a family story; the narrative shifts with each memory from another family member. My photographs preserve these collective memories. Creating visual diaries through black-and-white photographs allows me to tell stories in the tradition of African American story quilts. Quilts remind us of who we are and how our ancestors have influenced the larger society and ourselves. In constructing a photo story through memory, I situate my own family and the life of other African American families.

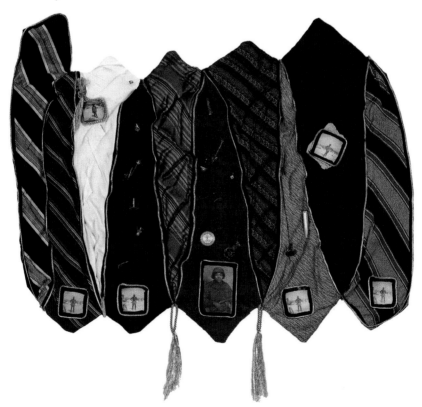

Daddy's Ties, 1992–Center for Creative Photography

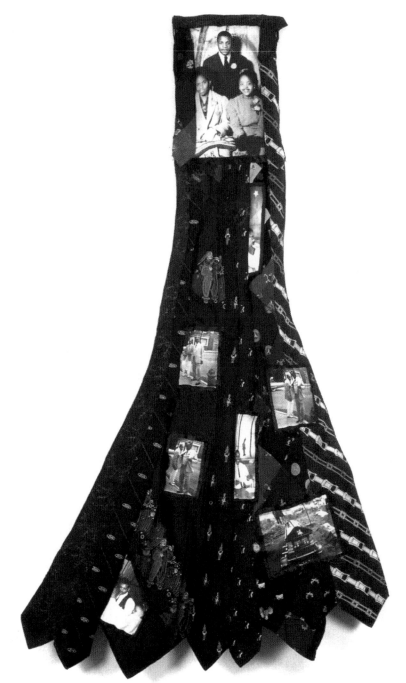

Mourning Ties, 1994

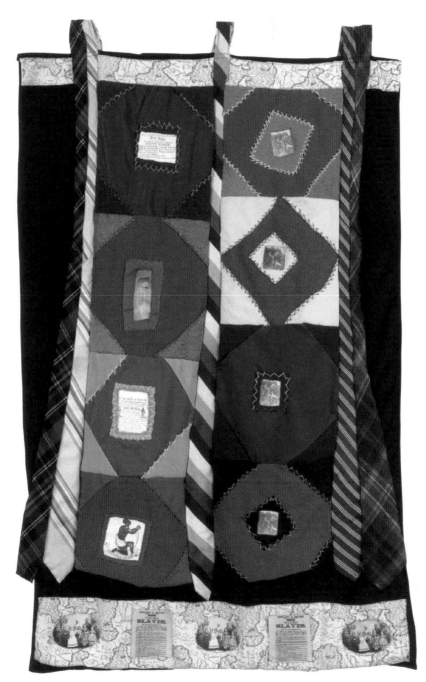

Enslaved, 1996

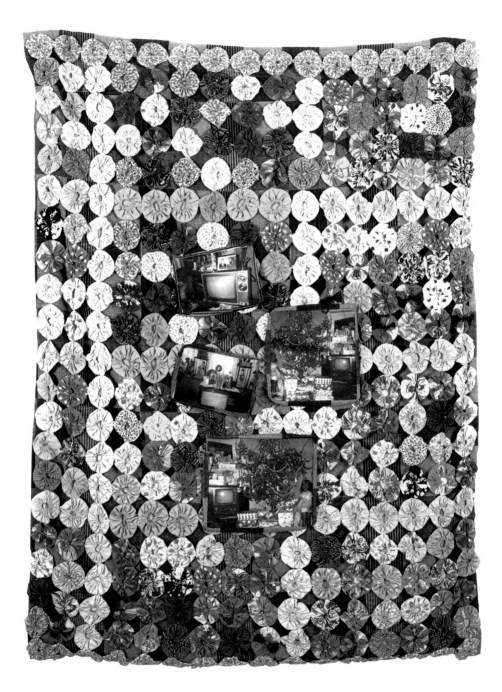

Date Unknown (Yo Yo Quilt), 1994

30

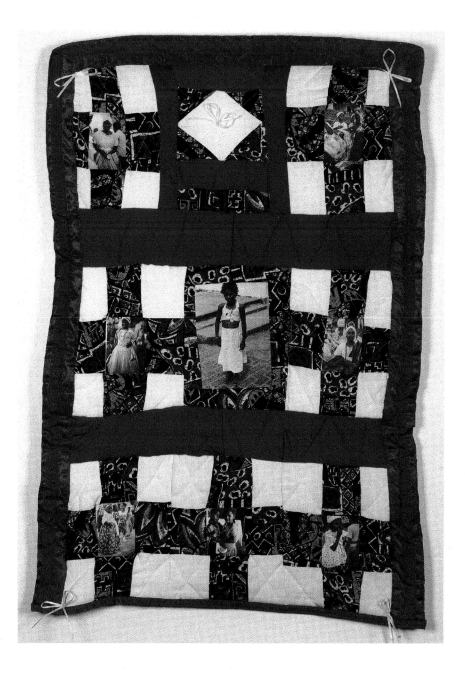

Brazilian Festival: Sisters of the Boa Morte, 1992

31

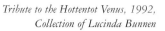
Tribute to the Hottentot Venus, 1992,
Collection of Lucinda Bunnen

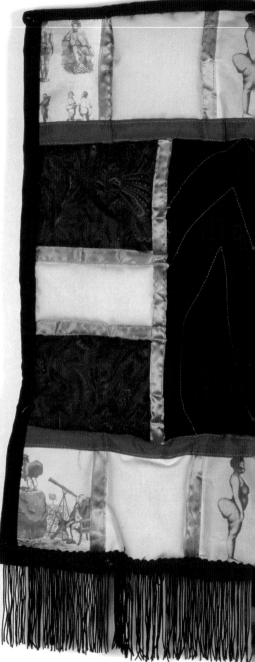

Photo Essay:
Family Album

Many of my childhood memories affected my early art-
work, where I attempted to recapture early memories, quiet
moments, and inspiring stories. I often think about my own
experiences as a black woman artist and imagine those of
other women artists who are considering and reconsidering
their own images. In doing so, it forces me to question what
we have imagined about black women and what has been
represented about us through art. By reinterpreting this
visual history, I merge gender, race, family, and public
history in an effort to become more aware of the visual
by decoding past and present images of black women.

I continue to photograph and to use my own family
photographs and archival references to incorporate stories
and social politics into my art, inviting a larger public to
imagine these experiences both collective and individual.

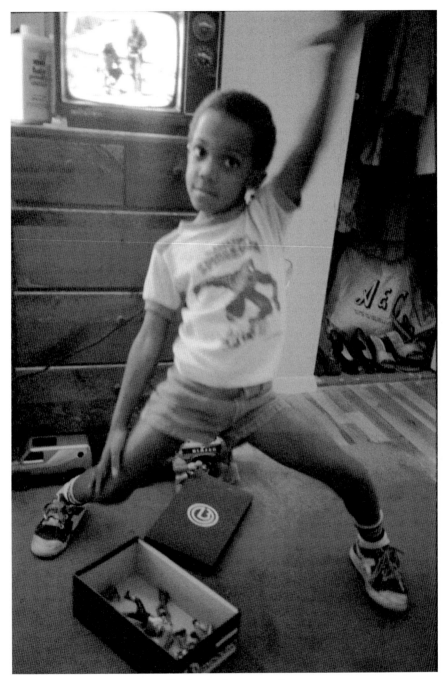

Hank posing for me at age 6

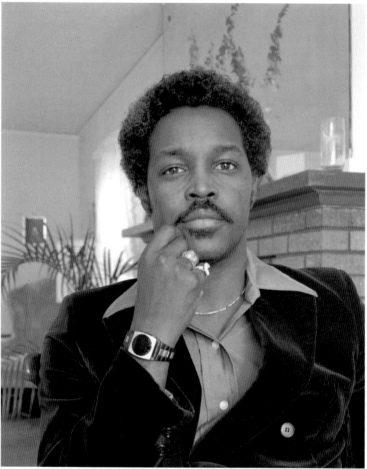

Hank's dad in Plainfield, 1976

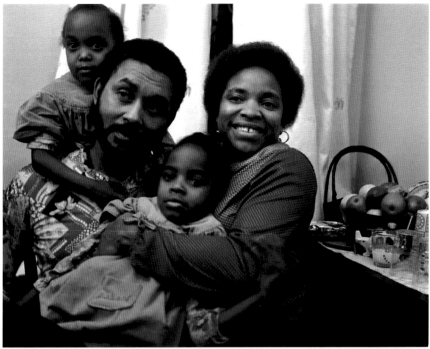

My sister Yvonne with Clarence and the twins, 1976

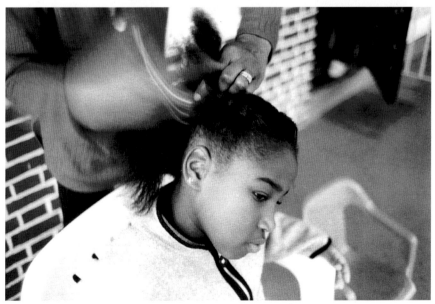

My sister Leslie braiding our cousin Gloria's hair, 1999

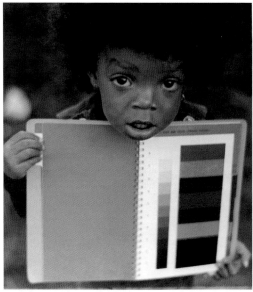

My niece Caran holding color chart, 1974

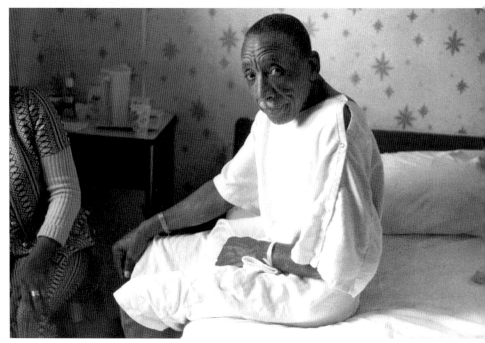

Grandpop Ernest in hospital, 1980

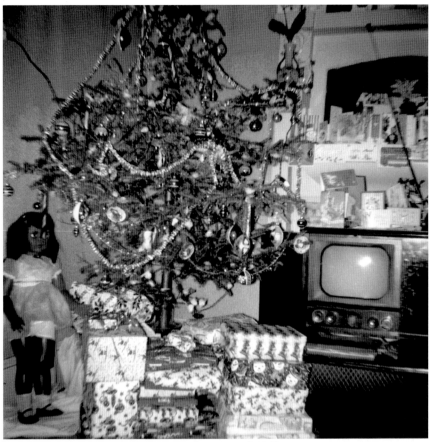

Christmas at our home in North Philly, 1958

Aunt Lil with group at Shady Grove Baptist Church, Virginia 1984

Cousins Bill and Veanie Lathan in Ardsley, 2001

40

Shady Grove Baptist Church Reunion, Virginia, 1984

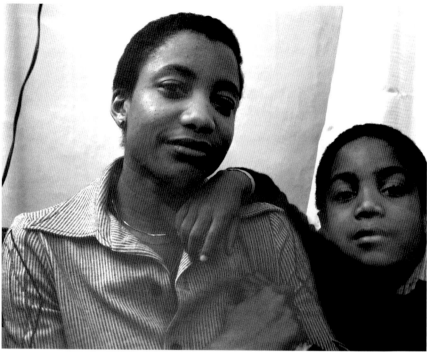

My sister Leslie with Songha, 1976

Tallahassee church, (Hank with C.H.I.P.S helmet in background), 1980

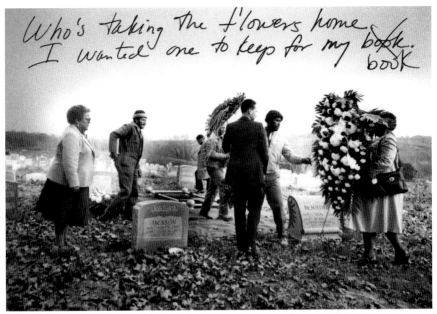

Grandmom Rose's burial site, 1986

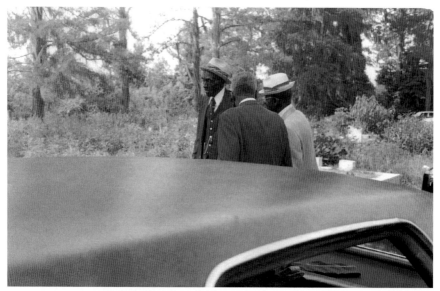

Uncle Brother's funeral, Florence, South Carolina, 1979

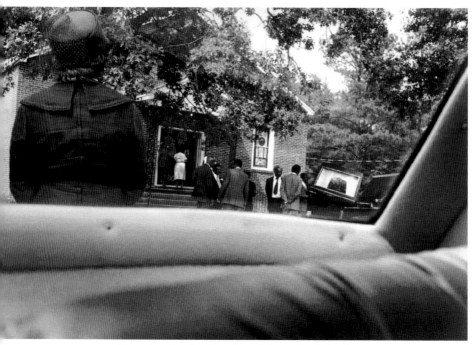

Funeral service, view from the car, Florence, South Carolina, 1979

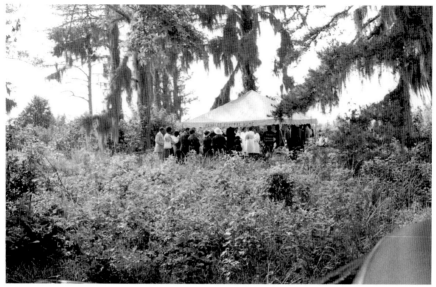

Funeral service, Florence, South Carolina, 1979

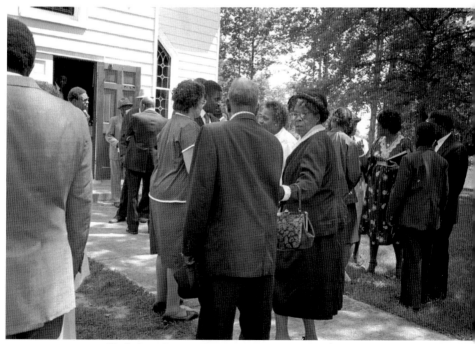

Shady Grove Reunion, Orange County, Virginia, 1984

45

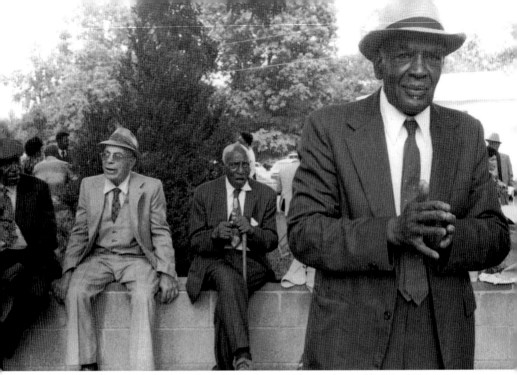

Shady Grove Reunion, (Uncle Lindsay with 3 men), Orange County, Virginia, 1984

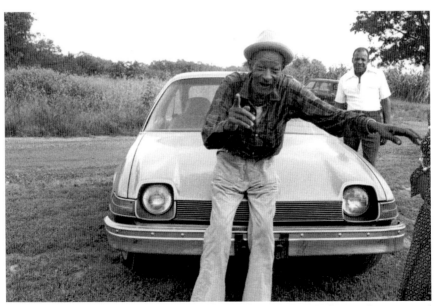

Orange County, Virginia – My father's cousin, Lindsay, my dad standing in back next to his Pacer, 1984

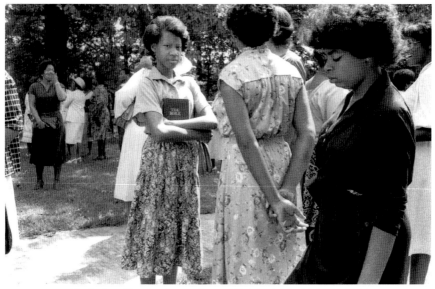

Shady Grove Reunion, Orange County, Virginia, (girl with Bible) 1984

Uncle Richard's living room in Chesapeake, Virginia, 1987

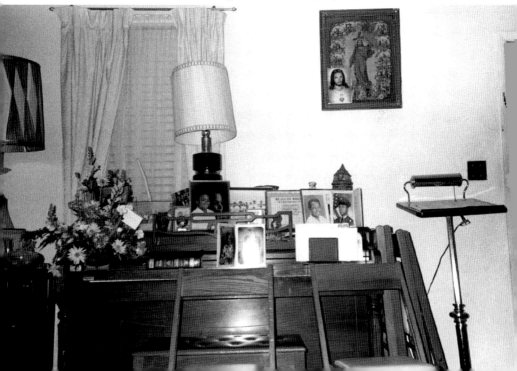

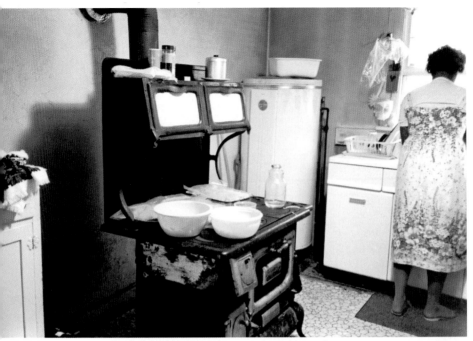

Kitchen in Orange County, Virginia, 1986

Mrs. Watson, Hank's babysitter

My mom, Ruth Willis, 1977

Photo Essay:
Beauty

I've always been interested in women at work, women taking care of their families. My mother—a beautician—worked at home, and I was fascinated by watching her with her clients. She was caring for them. Often, they were domestics, and they would leave work and come to our house to be beautified for church. I spent many hours sitting around listening to the stories of the women who were live-ins and day-workers who came on Fridays and Saturdays to get their white hair straightened, curled, and blue-dyed. They often spoke freely about the women they worked for, and shared stories about humiliating encounters.

Curling irons, Euro Salon, Eatonville, Florida 2003

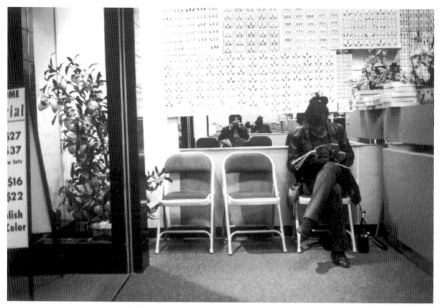

Self-portrait in nail shop, Durham, N. C., 2001

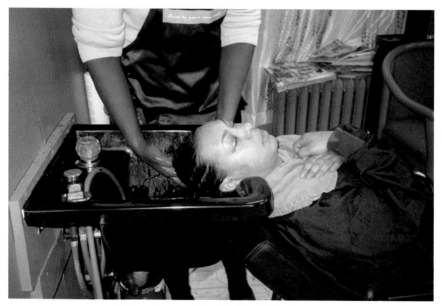

Kellie – shampoo at Done Up, New York City, 2003

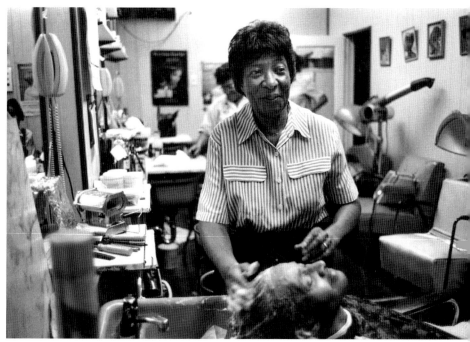

Shampoo at Mrs. Brown's shop, Philadelphia, 1999

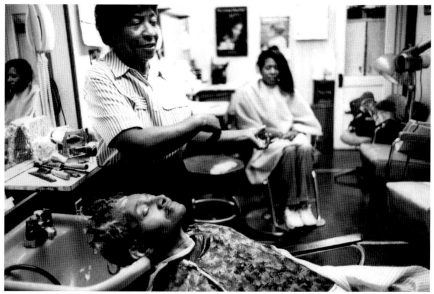

Mrs. Brown's shop, Philadelphia, 1999

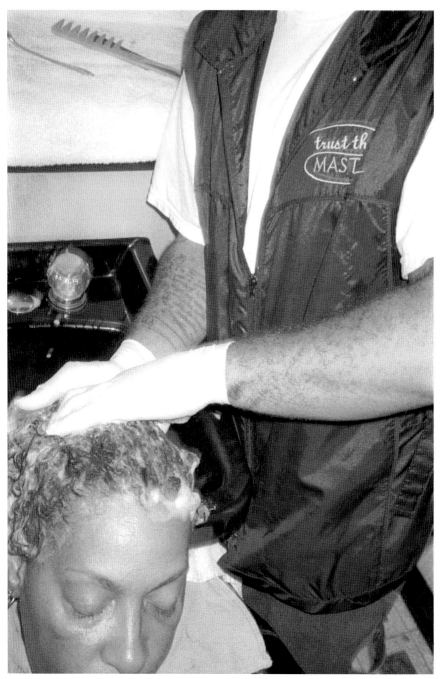

Carrie's shampoo, Euro Salon, Eatonville, Florida, 2003

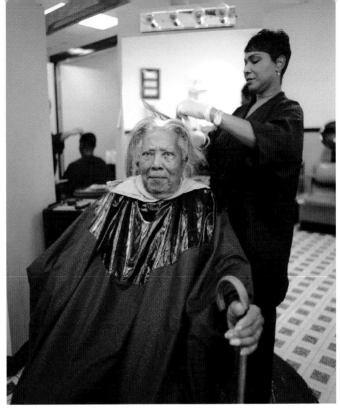

Euro Salon, Eatonville, Florida, 2003

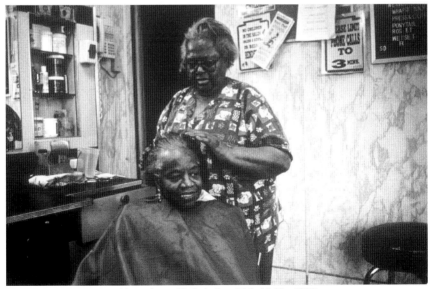

My mother at McGee's shop, Philadelphia, 1999

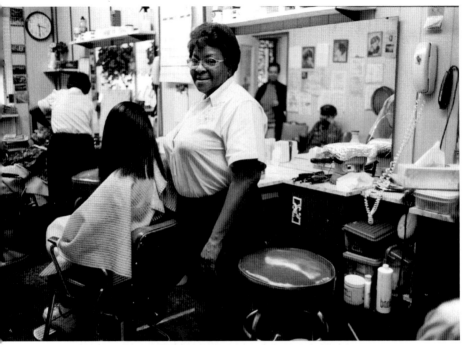

Press and curl at Mrs. Brown's shop, Philadelphia, 1999

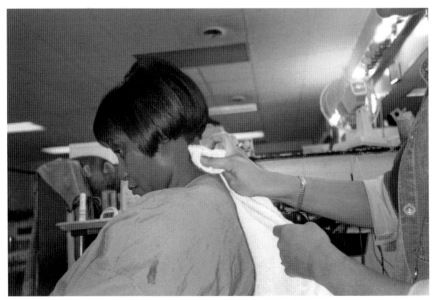

Shape up, Studio Salon, Durham, N.C., 2001

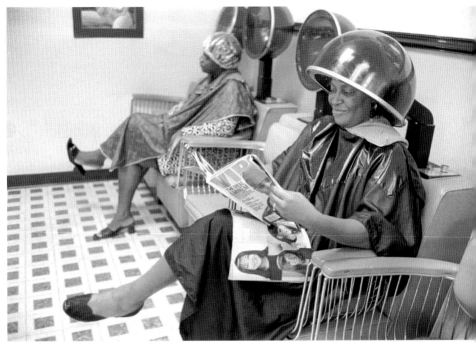

Drying time, Eatonville, Florida, 2003

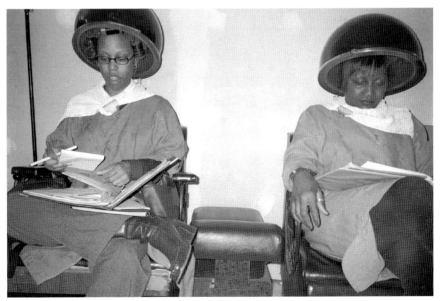

Drying time, Durham, N. C., 2001

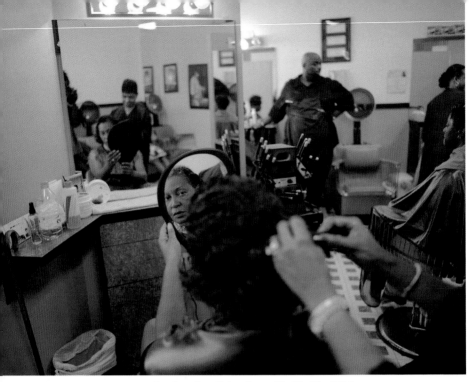

Carrie at Euro Salon, Eatonville, Florida, 2003

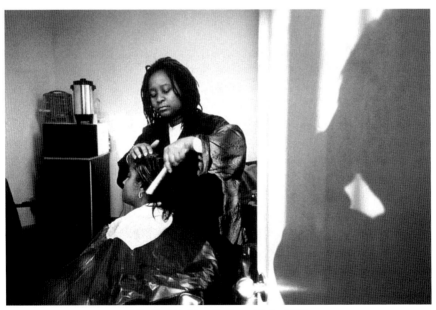

Miss Barbie's Shop, Durham, N. C., 2001

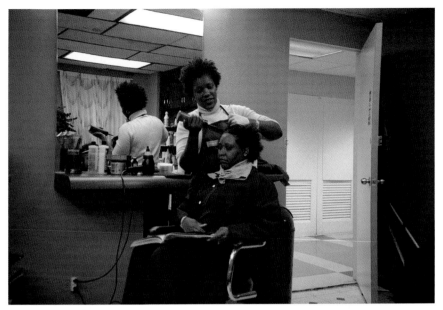

Red dye at Done Up Salon, New York City, 2003

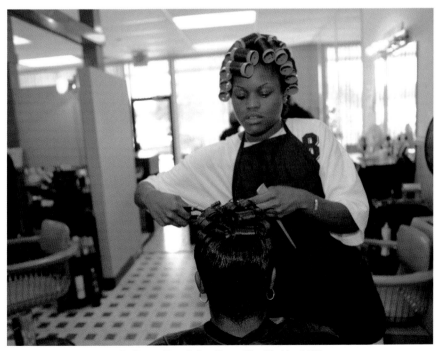

Stylists at Euro Salon, Eatonville, Florida, 2003

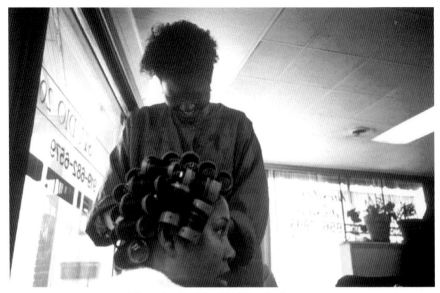

The set, Studio Salon, Durham, N. C., 2001

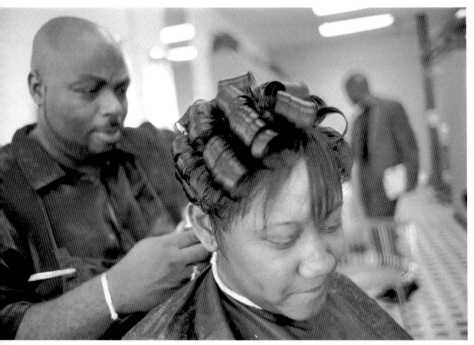

Male stylist at Euro Salon, Eatonville, Florida, 2003

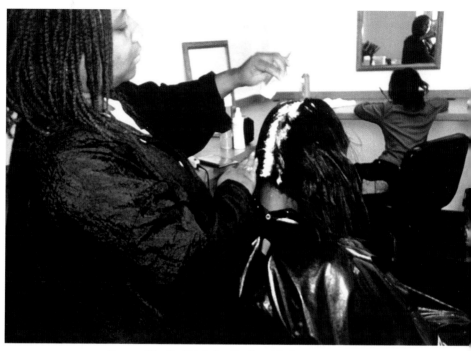

Perm at Miss Barbie's Salon, Durham, N. C., 2001

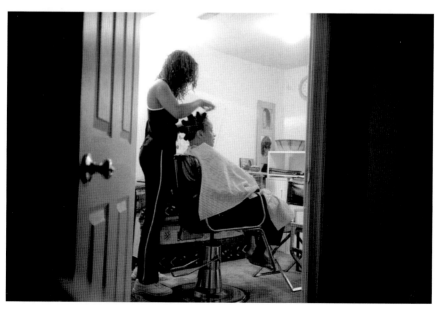

Self-portrait at Shani's shop, 2001

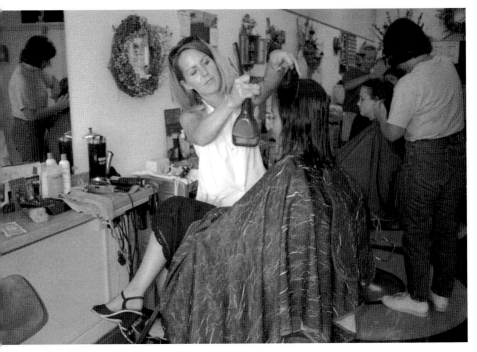

Claudia in salon, Leesburg, Virginia, 2001

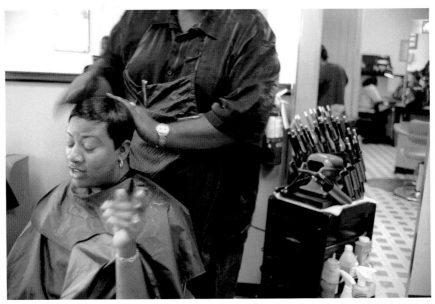

Dubbie wrap at Euro Salon, Eatonville, Florida, 2003

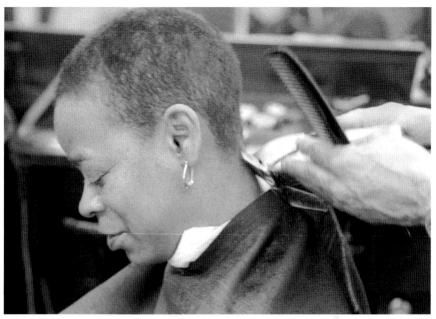

Sharon's haircut at Salih Talib's shop in Harlem, 2004

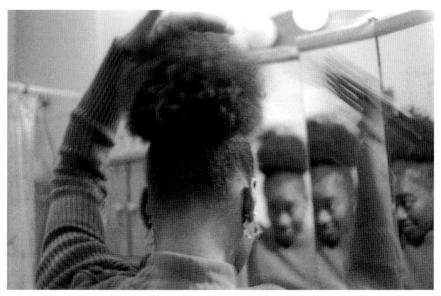

Ronda styling her hair in the mirror, Philadelphia, 2000

Photo Essay:
Bodybuilding

In the *Bodybuilder* series, I focus on work and how it can be manifested physically in the black female body, shorn of covering. In these photographs of body builder Nancy Lewis, I concentrate on developed and amplified muscles and tendons, shoulders, and backs. The depiction of physical work and its impact on the development of the body has often been relegated to men, as if the world of physical work were gender-specific. This series shows how the image of the black female body, when viewed through the lens of actual work, can be one of physical and not just figurative or emotional strength.

Nancy Lewis, Bodybuilder, 1998

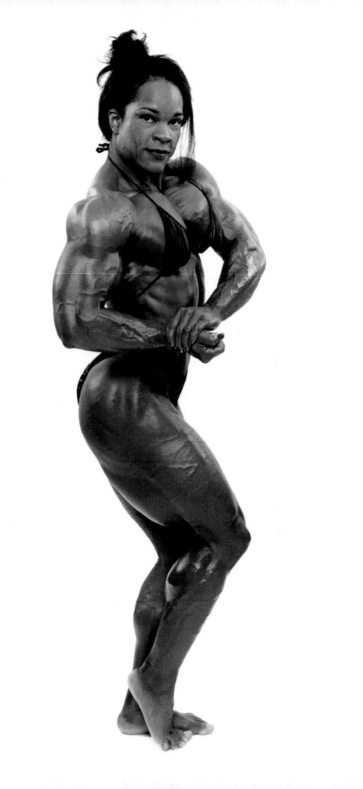

Bodybuilder series, "Red Nails" 1998

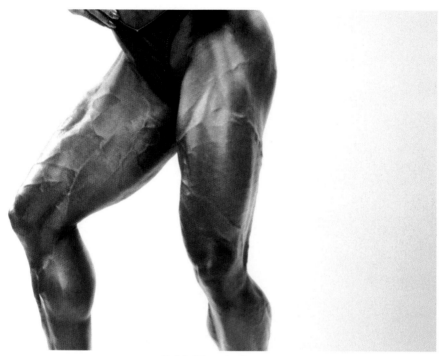

Bodybuilder series, legs, 1998

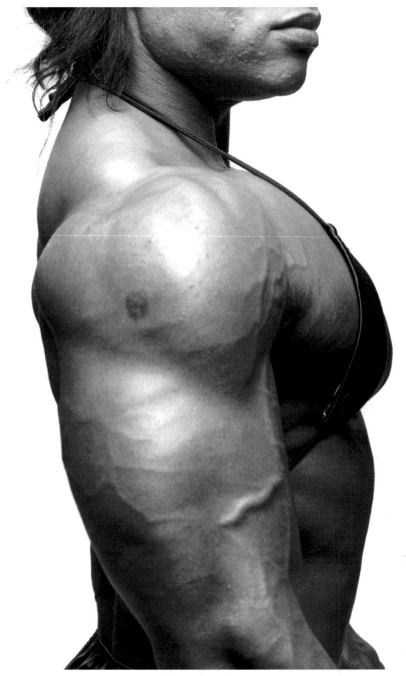

Bodybuilder series, profile, 1998

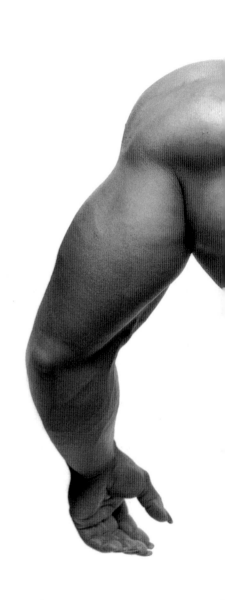

Bodybuilder series, 1998

70

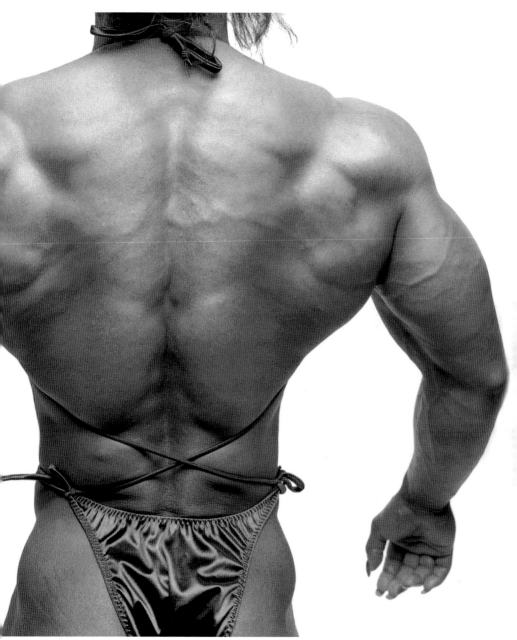

Bodybuilder series, back, 1998

Cancer Diaries

I was diagnosed with breast cancer on May 2, 2001 on
the anniversary of my nephew's death. I was shocked. I had
routine breast exams since I was 40 years old and never
thought about cancer becoming a reality. I was asked to
come in that day to George Washington University
Hospital for a biopsy. I was told that same day that I had to
make an appointment with my surgeon. How does one find
a surgeon, I thought. I was in the midst of my project on
beauty salons. I was devastated. I decided to photograph
the changes in my body when I felt well enough to do so.
I also wanted to photograph the moments when I felt lost
so I would have a visual diary about the experience from
diagnosis through chemotherapy.

Self-portrait, (Bald 3 days), 2001

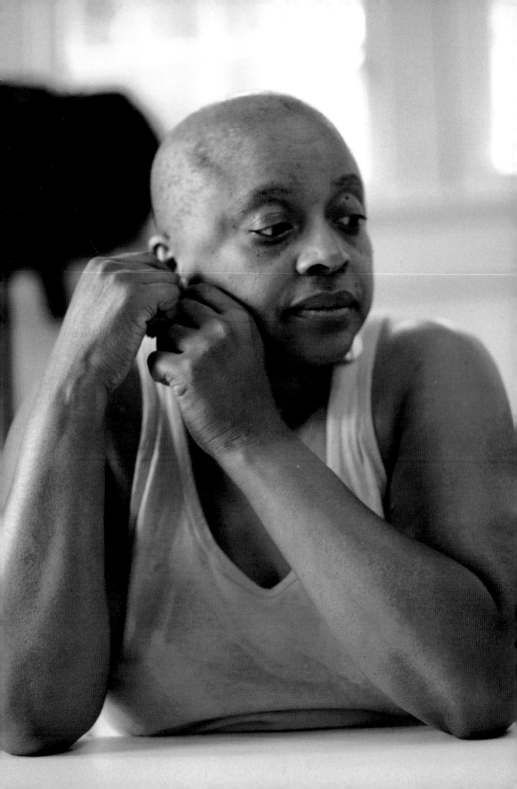

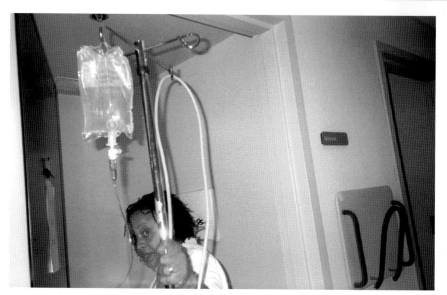

Chemo, third week, trimming of the sisterlocks, 2001

Chemo, first day, GW Hospital, Washington, D.C., 2001

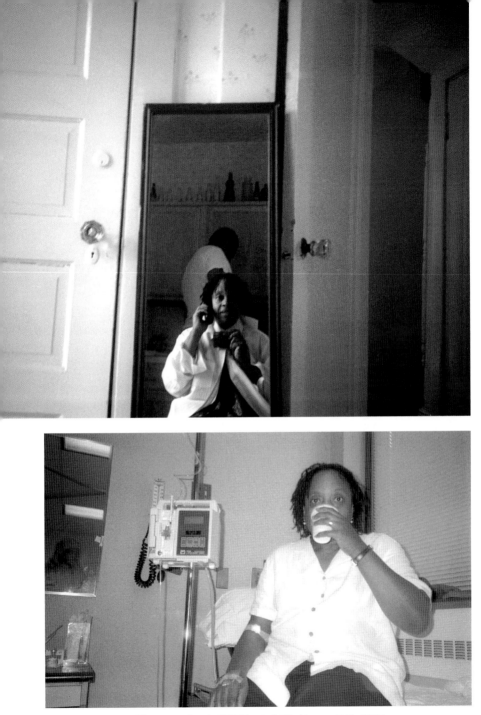

Chemo, second week, GW Hospital, Washington, D.C., 2001

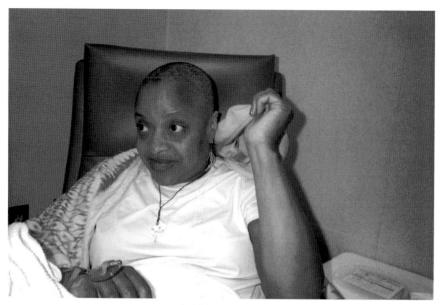

Chemo, 2 weeks, 2001

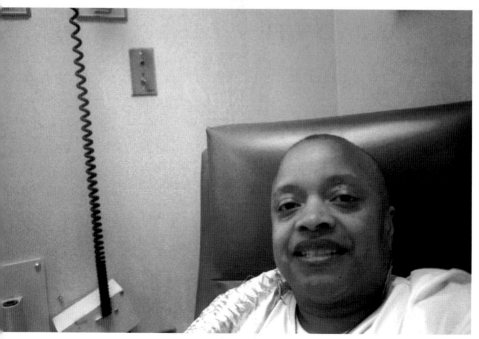

Chemo, 6 weeks, 2001

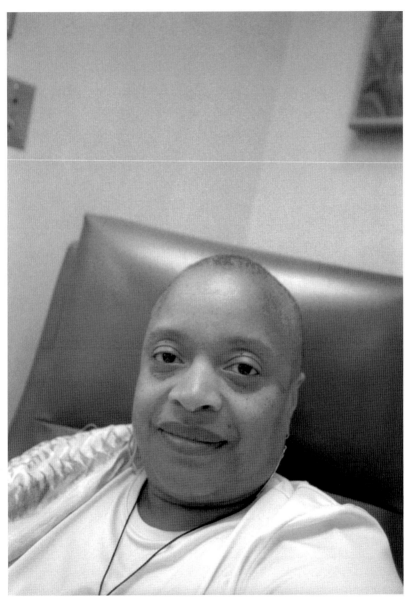

Chemo, 6 weeks, 2001

GW Hospital, Monitoring, 2001

IV, 2001

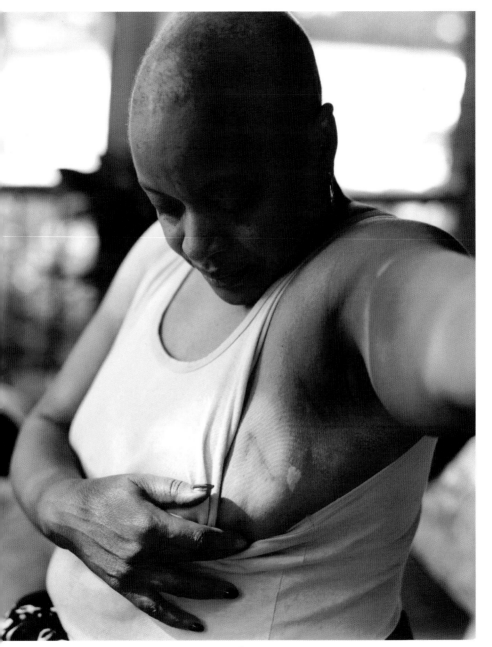

The scar, 2001

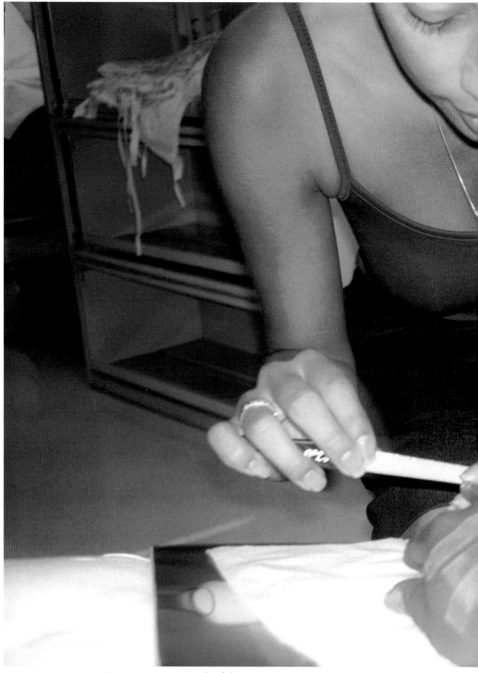

Sing manicuring my nails while I get treatment, 2001

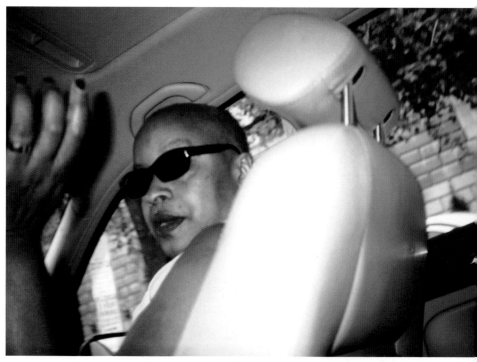

Leaving hospital, 2001

At home in D.C., feeling sick from the treatment, 2001

In living room in D.C., tired, 2001

Photo Essay:
Palestine

In 1989, I traveled to Palestine. The experience was transformative—looking at 13 year-old boys and one girl who were shot with rubber bullets and thinking of my own kid who was 13 at the time. I wondered if I would be able to give my kid's life for my land.

"He said 'Call me Kojak'" A young man in a Gaza Hospital, 1989

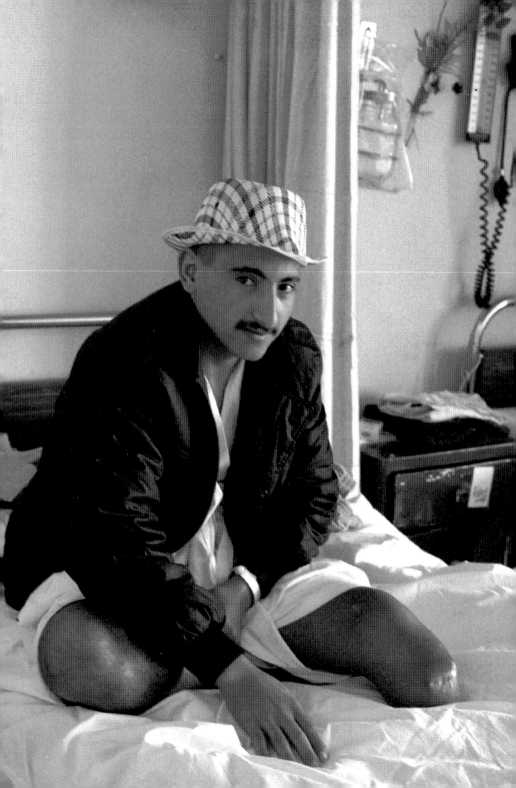

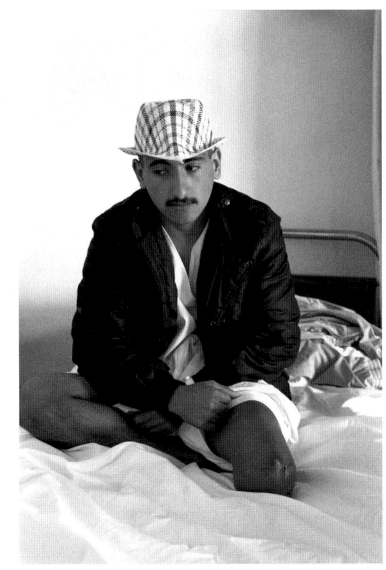

Amputee, young man, Gaza Hospital, 1989

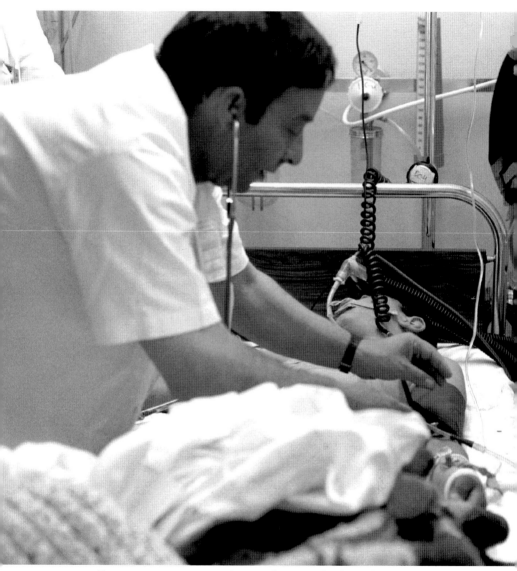

Emergency Room, Gaza Hospital, 1989 (doctor treats boy shot with rubber bullet)

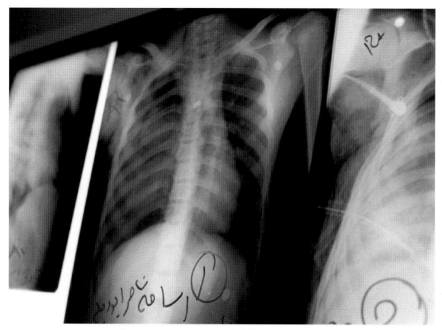

Emergency Room, Gaza Hospital, 1989, X-Rays

Emergency Room, Gaza Hospital, 1989, X-Rays

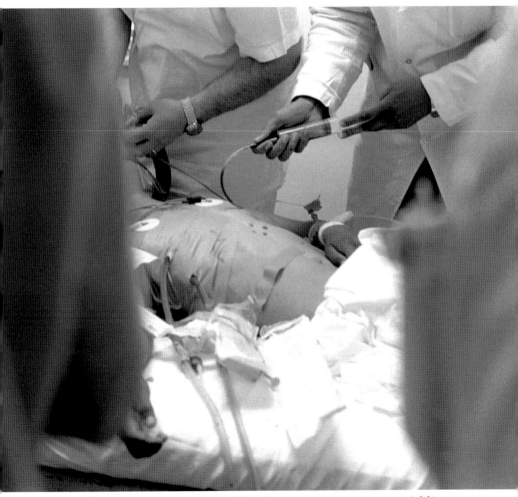

Emergency Room, Gaza Hospital, 1989, (doctors attempt to save a young man's life)

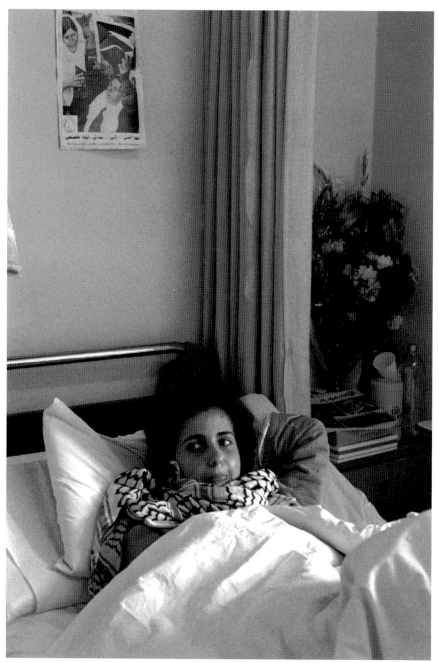

Young girl in Gaza Hospital room, 1989

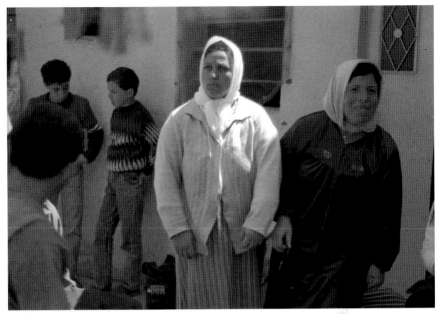

Mothers with their sons, East Jerusalem, 1989

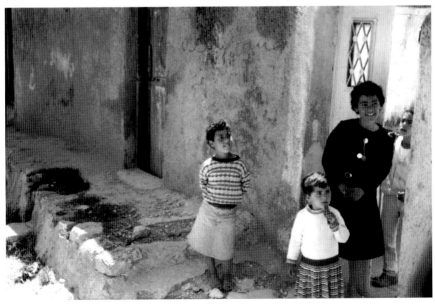

Children posing outside their home in East Jerusalem, 1989

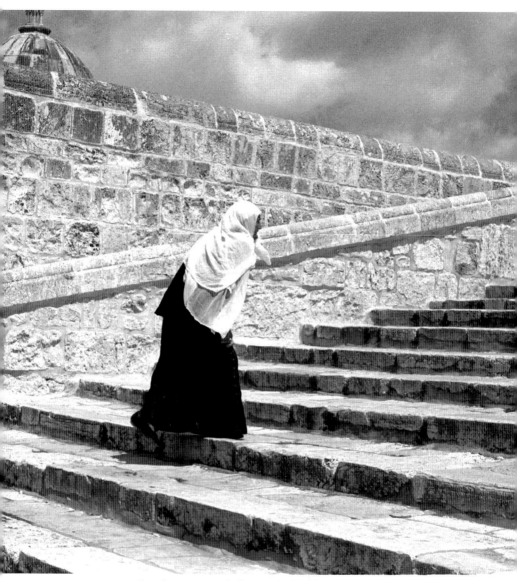

Jerusalem, a woman climbs steps outside of the Mosque, 1989

Mothers, Jerusalem, 1989

Interior of home showing portrait of deceased son, 1989

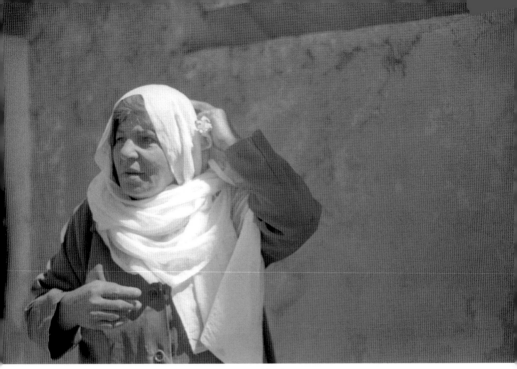

Woman outside of her home, 1989

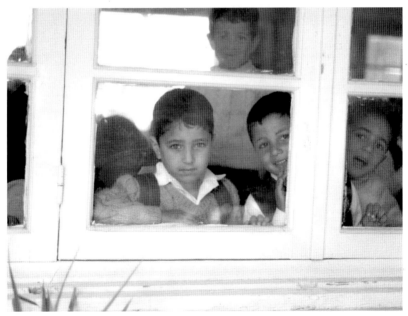

School children looking out window, 1989

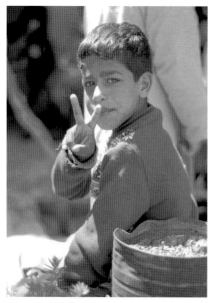

13 year-old Palestinian giving peace sign outside of his home in Jerusalem, 1989

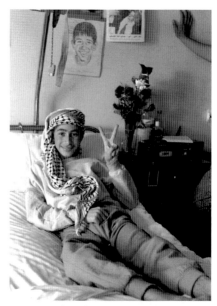

13 year-old Palestinian giving peace sign in hospital room, 1989

13 year-old Palestinian giving peace sign outside his home, 1989

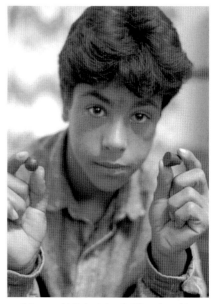

13 year-old Palestinian holding the rubber bullets that injured his face, 1989

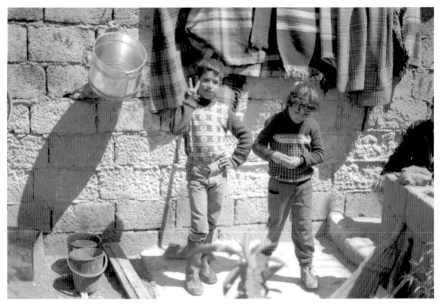

Palestinian children outside of their home, 1989

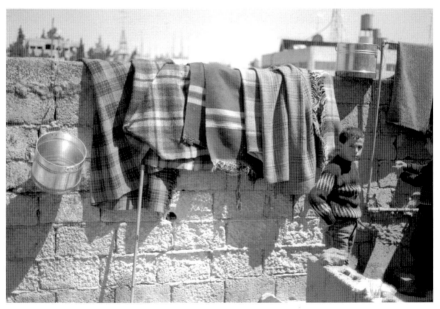

Palestinian boy near wall with buckets and blankets, 1989

97

Photo Essay:
City Scenes

Documenting life in the city is important to the story-
telling aspect of my work. I like to watch the people on the
subways, on the streets and in the cities. This section
informs my interest in documentary photography.

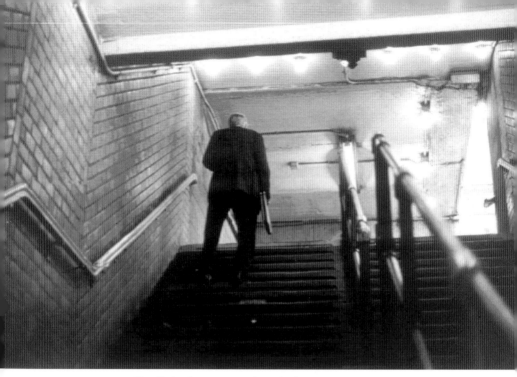

New York subway, stairs at 42 and 5th Avenue exit, 1981

North Philadelphia train station, 1981

New York City, 49th Street, 1984

New York subway, shuttle at Grand Central, 1983

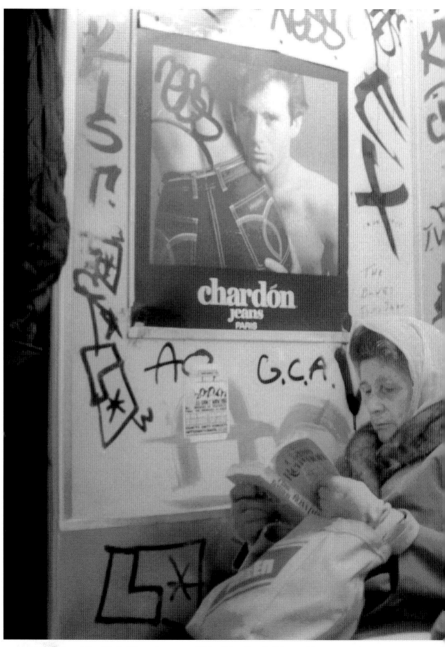

New York City subway, graffiti with ad and riders, 1983

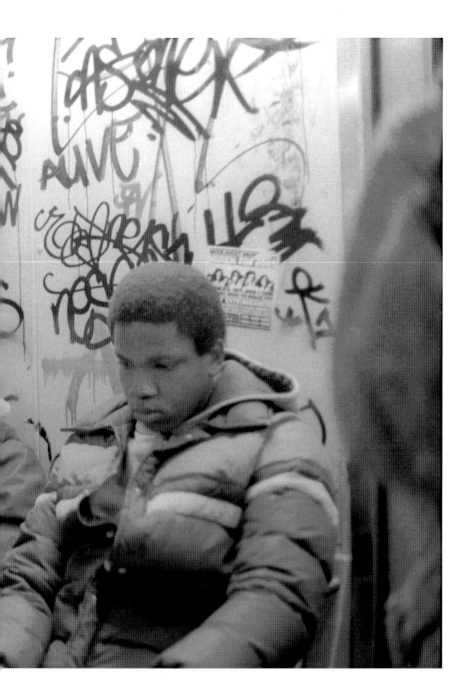

New York City tourists, c.1985

New York City, West 23rd Street, 1980

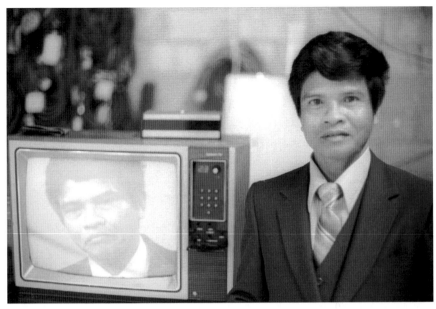

New York City, Asian tourist on tv monitor, c. 1985

New York City, 42nd Street

Staten Island Ferry, 1981

Sailor on ship at the Philadelphia Navy Yard, 1980

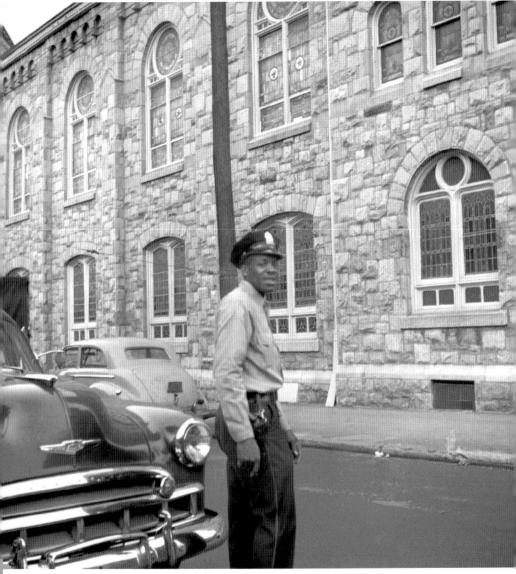

My father on the beat, c. 1960s

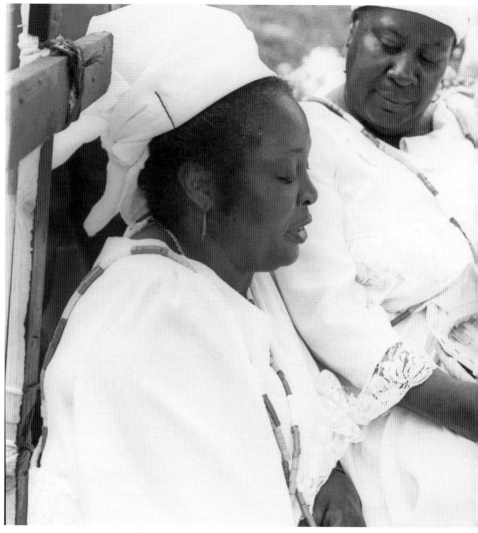

Ceremony in Brooklyn, New York 1979

Street ad in Venice, 2003

Posters in Venice, 2003

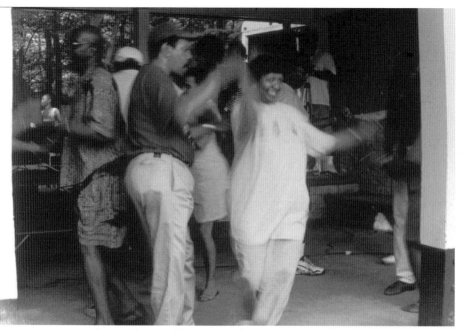

Hand dancing in park in Maryland, 2001

Church in East Harlem, 116th Street, 1979

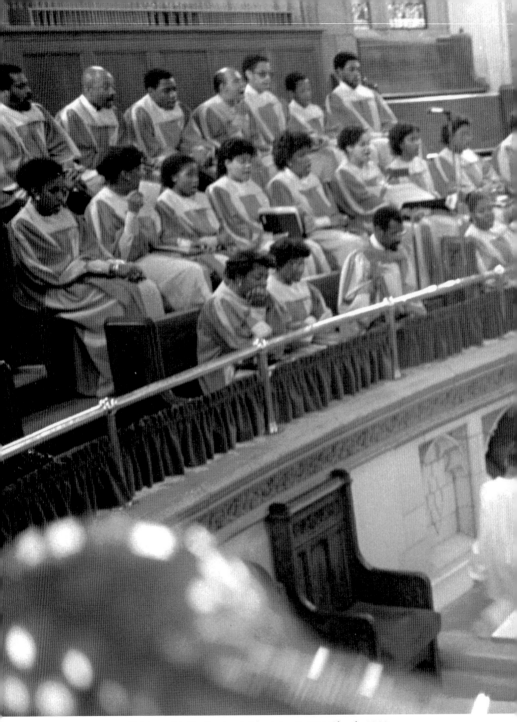

Baptism with Dr. Proctor at Abyssinian Baptist Church, 1983

Filmmaker and professor, Manthia Diawara in his office at New York University, 2002

Manthia Diawara with writer, Walter Mosley at New York University, 2002

Visiting sailors on the Staten Island Ferry, 1981

Ninth Street, South Philadelphia, with Caran, 1978

Visiting sailors on the Staten Island Ferry, 1981

Ninth Street, South Philadelphia, with Caran, 1978

Odunde Festival, South Street, Philadelphia, 1980

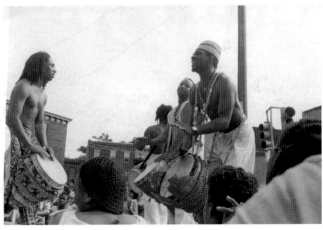

Odunde Festival, South Street, Philadelphia, 1980, (drummers)

117

Odunde Festival, South Street, Philadelphia, 1980, (windows)

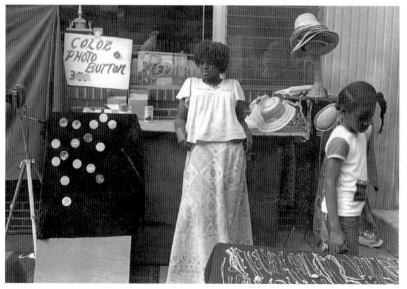

Odunde Festival, South Street, Philadelphia, 1980, (hats)

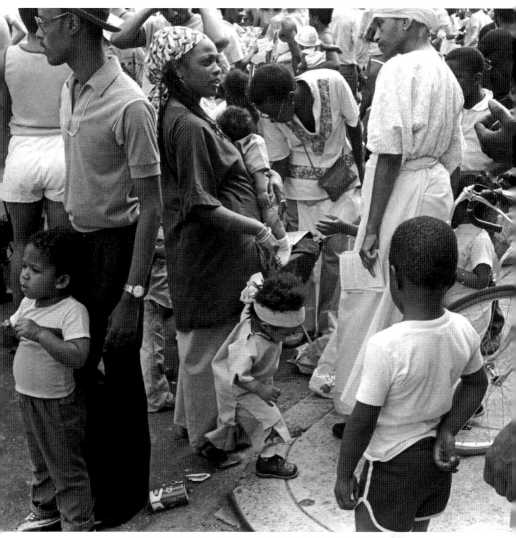

Odunde Festival, South Street, Philadelphia, 1980, (families)

New York City, Flatiron Building, 1980

New York City, celebration in East Harlem, 1979

New York City, festival with musicians, in East Harlem, 1979

121

Photo Essay:
Shotgun Houses

I am interested in how beauty is manifested in African American culture, from the physicality of the body to the architectural structure of the home. In the 1800s, shotgun houses were home to the working class, free blacks, and immigrants. These homes were inexpensive to build and on small lots making them affordable to people who dreamed of owning their own home. They may be the only African American building type in American architecture. Folklore attributed the name "shotgun house" to the notion that a bullet fired through the front door could go straight through the house and out the back door due to the linear arrangement of rooms. Some scholars argue that these one-story houses with narrow widths reflect African building traditions that entered the American Southeast via the trans-Atlantic slave trade through the Caribbean Islands. My work imagines this history and the lives of the women who lived in the homes.

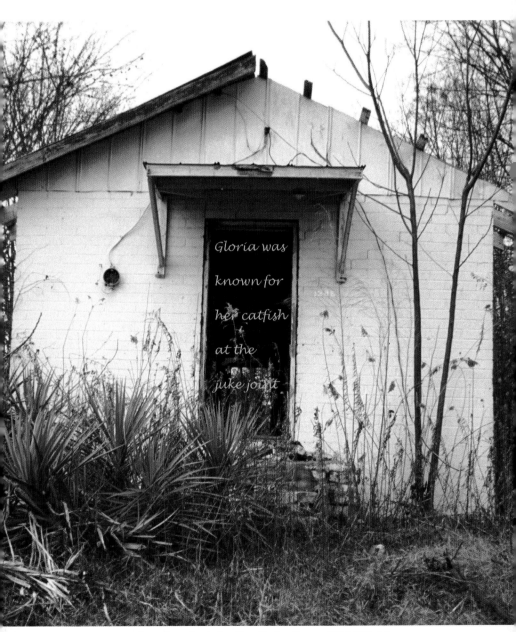

Gloria was
known for
her catfish
at the
juke joint

Orangeburg, South Carolina, Hudson Bottom, 2002 (Gloria)

Orangeburg, South Carolina, Hudson Bottom, 2002
(iron shirts)

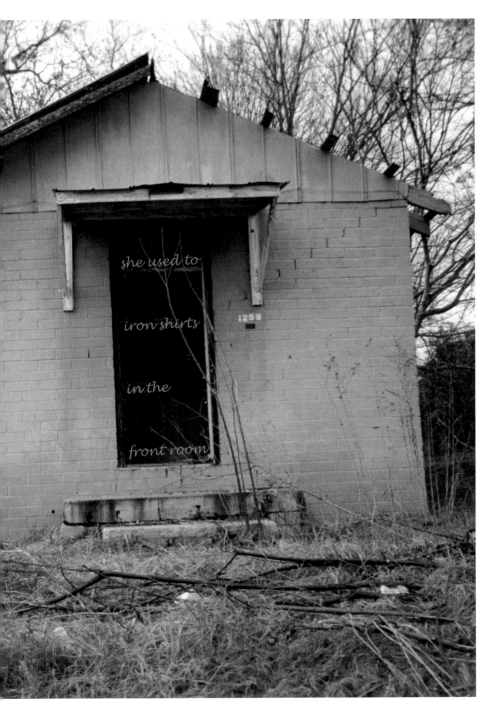

she used to

iron shirts

in the

front room

Orangeburg, South Carolina, Hudson Bottom, 2002 (Mary)

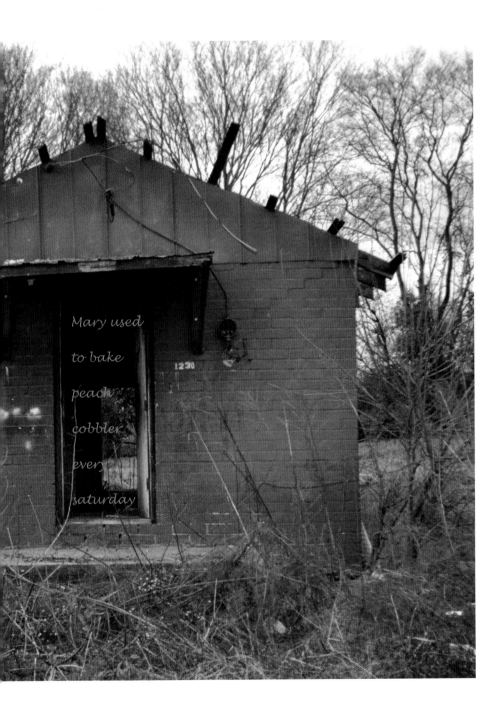

Mary used
to bake
peach
cobbler
every
saturday

Orangeburg, South Carolina, Hudson Bottom, 2002 (Ruth)

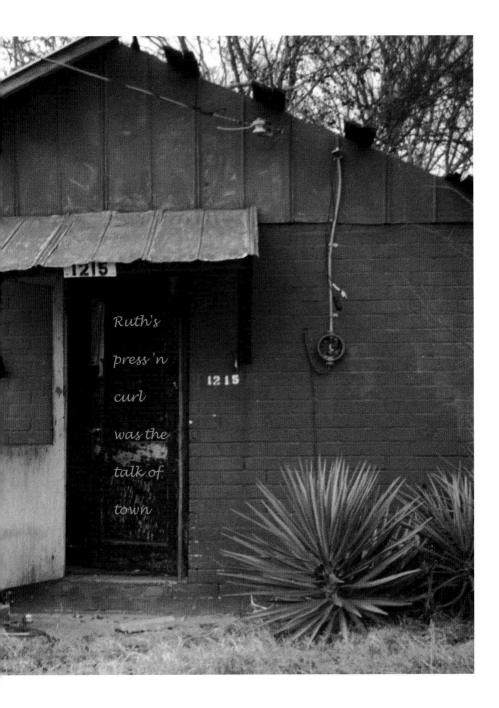

.1215

Ruth's
press 'n
curl
was the
talk of
town

1215

The "shotgun" house is one room wide and three or four rooms deep. They were owned first by free blacks in the south

Previous page: Orangeburg, South Carolina, Hudson Bottom, 2002 (Shotgun)

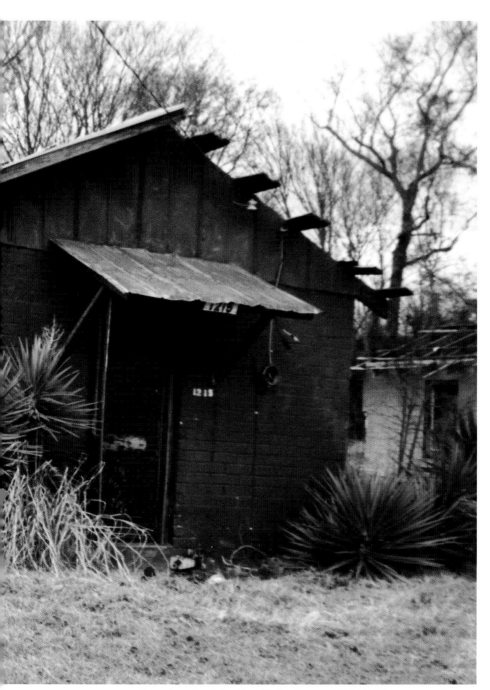

Orangeburg, South Carolina, Hudson Bottom, 2002 (1215)

African Diaspora

These photographs are of young Brazilian girls and older women living in Bahia. Dressed in traditional dress, they dance and pay tribute to the women elders of the city of Cachirea. The Sisters of the Boa Morte is an organization that was begun after slavery in the later 1860s by freed African-Brazilian women who were concerned about the condition and future welfare of the older women. The current members honor this spiritual and productive group. The Cuba photographs are of Fidel Castro from my hotel room in Havana. In 1970 I spent six weeks in Ghana photographing ceremonies, the countryside and people. Traveling to South Africa in 2003 I found similarities in the homes of people living in South Carolina and in townships such as Langa and others near Johannesburg and Cape Town. Women and men decorated and designed their homes with lace curtains and vibrant colors, reminding me that beauty matters, whether living in public housing, fabricated houses or a middle class environment.

Young girl on platform, Cachirea, Brazil, 1988

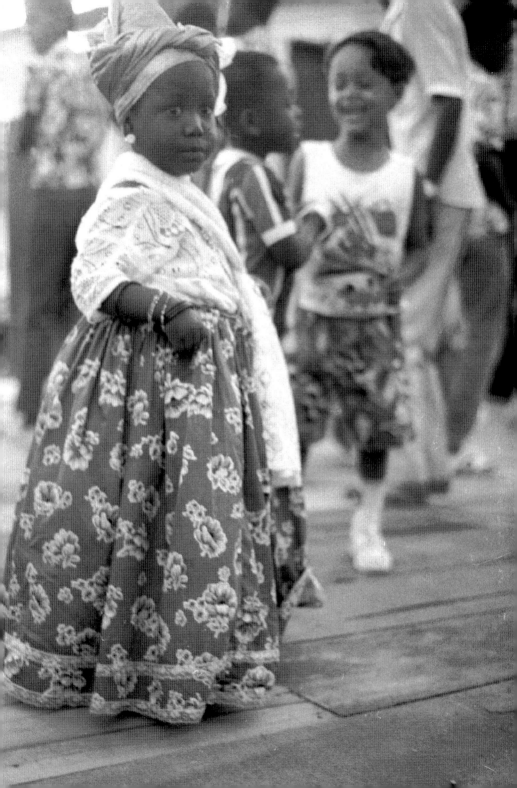

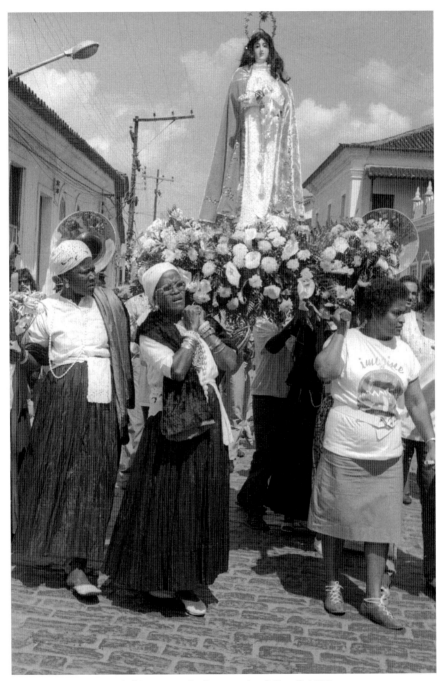

Cachirea, women leading processional, Brazil, 1988

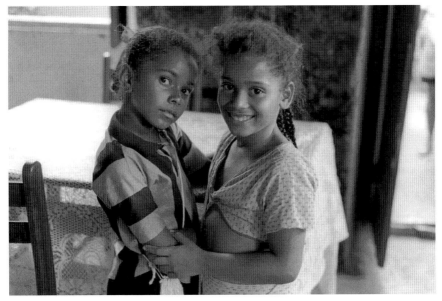

Two girls, Brazil, 1988

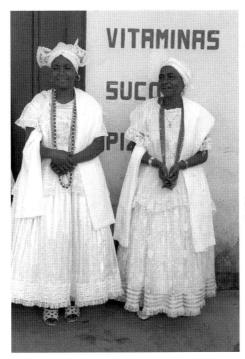

Two women, Brazil, 1988

137

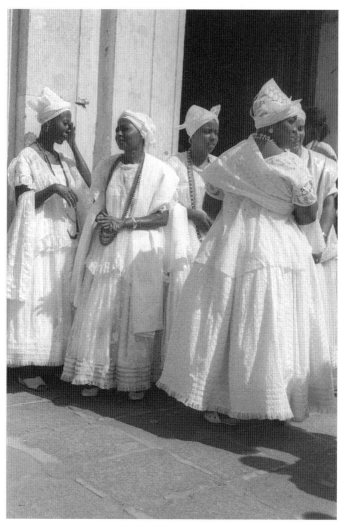

Women waiting outside church, Brazil, 1988

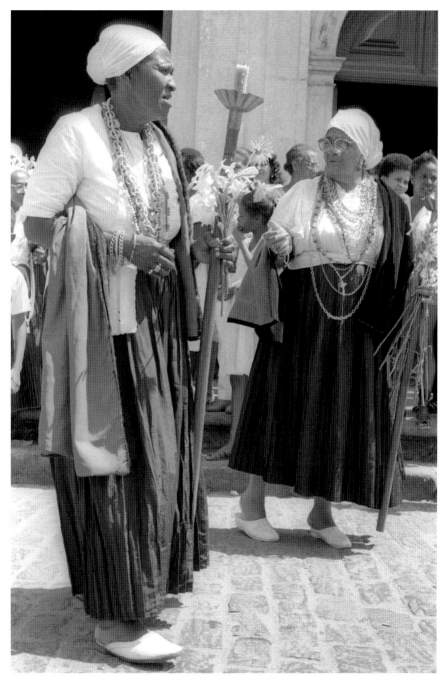

Women holding candles, Brazil, 1988

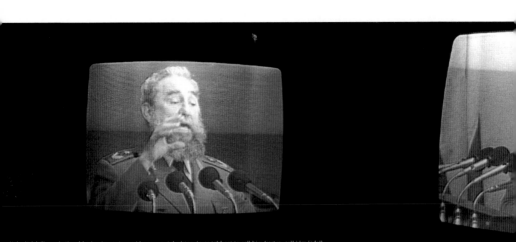

Cuba Fidel. The only time I had a chance to see him was on television. I was told not to call him Castro, call him Fidel!

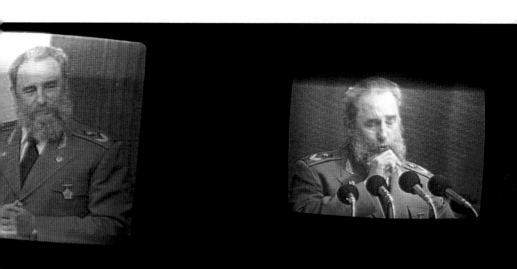

Fidel Castro on television, 1987

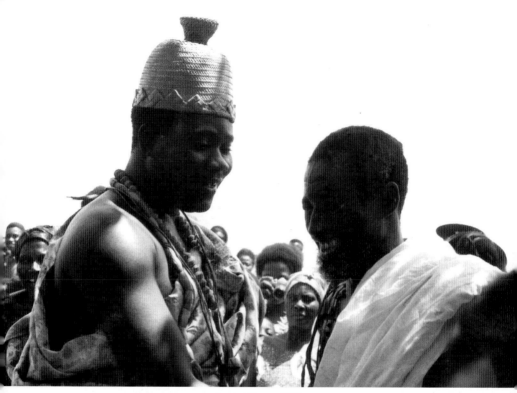

Accra, Ghana, 1970

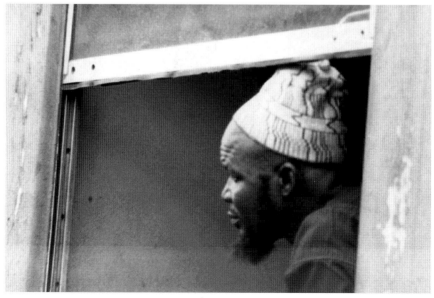

Man on train to Kumasi, 1970

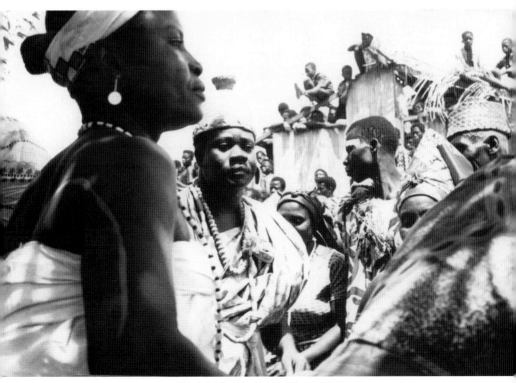

Fanti Celebration, Accra, Ghana, 1970

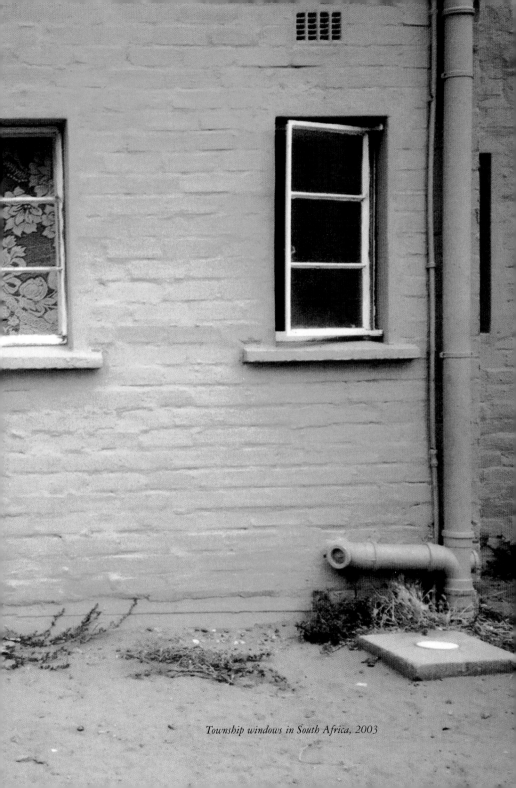

Township windows in South Africa, 2003

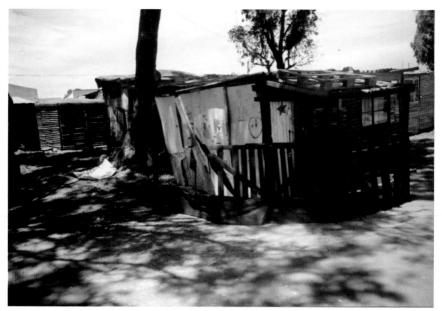

Township home, 2003

Interior of home, 2003

146

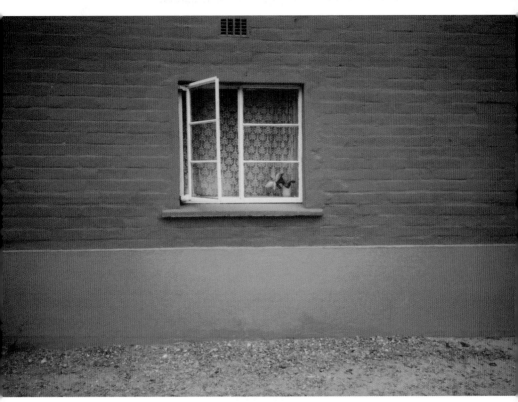

Window, 2003

Township home, 2003

Photo Essay:
Hip Hop

For a number of years I have focused my work on images of black women's bodies by looking at Hip Hop culture I am attempting to explore fashion, style, and agency.

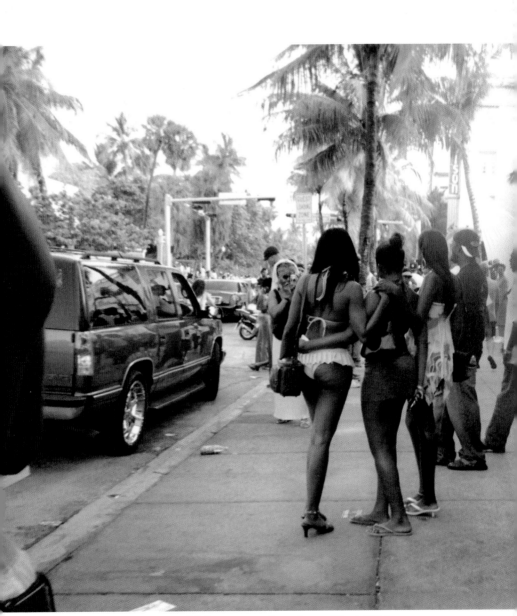

Hip Hop girl fashion, posing on Ocean Avenue, Miami, 2004

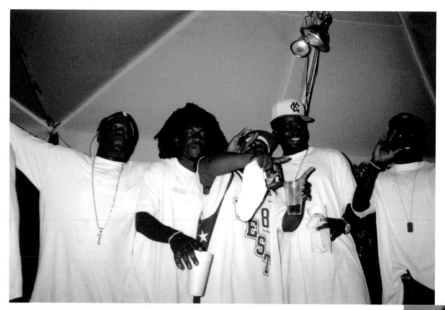

Young men freestyle on Ocean Avenue, Miami, 2004

153 South Beach, "Just met" posing for picture at pool, 2004

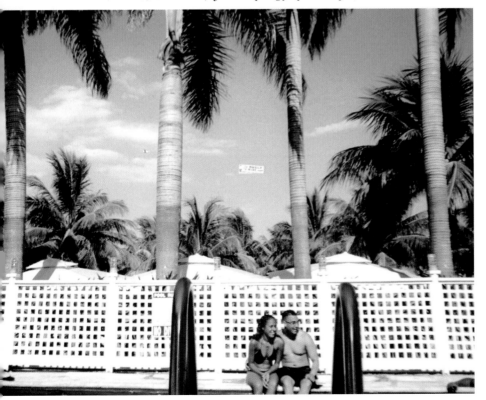

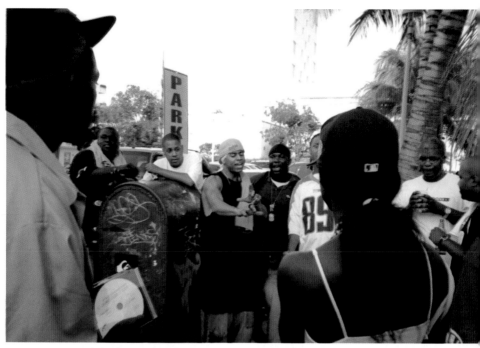

Performing on Collins Avenue street corner, Miami, 2004

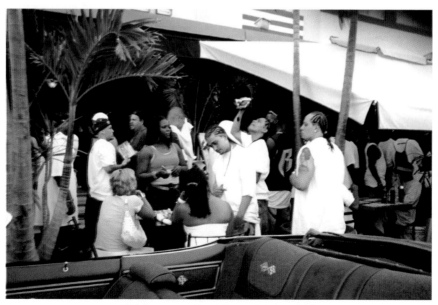

Video cameras on Ocean Avenue, Miami, 2004

Hip Hop fashion, Miami, 2004

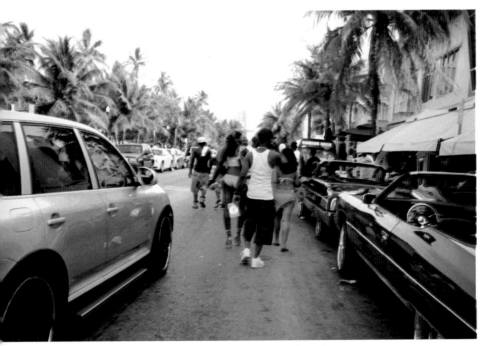

Ocean Avenue, Miami, 2004

Selected Essays

Just as black photographers and their subjects have re-written American history, Deborah Willis re-writes the history of American photography by demonstrating that the descendants of slaves were among the genre's chief innovators.

—Robin D.G. Kelley

Family

Visualizing Memory: A Photographic Study

The photograph is an instrument of memory, one that explores the value of self, family, and memory in documenting everyday life. Photographing friends, family members, and objects is a transformative act, one that can instill a sense of joy and dignity in both the photographer and the subject. Since the beginning of photographic history, family photographs have had a special connection to the viewer. They can be viewed as evidence of a special event and used to illustrate a story. As a photographer, educator, and curator, I have used photography to tell stories about family life and have asked students and artists to use the photograph in a narrative form to explore personal memories.

I was a young girl growing up in North Philadelphia when I became aware of the photograph as an important storytelling device. My father was the family photographer and his cousin owned a studio near our house. We were often photographed by both of them and later, I spent many hours placing their photographs in the family album. This was in the 1950s and early 1960s and the small number of television shows depicting the black family did not portray what I experienced in my own family.

We had black dolls, and images of black life hanging on our walls and placed on the mantel. My mother had a beauty shop in our house where she "did" the hair of women in the neighborhood. I spent hours watching her, but I also spent a lot of time in front of the television, looking at books and magazines—as many as I was allowed between chores and homework—and found myself noticing how different our lives were from the published and televised images. Those images did not reflect what I saw at home. Only *The Sweetflypaper of Life*, by Langston Hughes and Roy DeCarava, which I discovered one Saturday at the library, had any resonance for me.

While a student at Temple University in 1968, I began working for

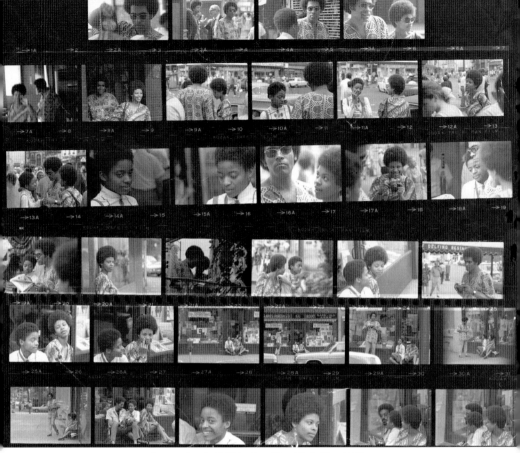

Contact sheet by Bill Lathan, New York City, 1969

the Center for Community Studies. I traveled often to West Virginia with the staff to assist in setting up employment training for families living in Appalachia. I thought about my own family life and wanted to take photographs on my trips there to document the work of the VISTA volunteers and the families they assisted. I wondered how I could accomplish this without the "outsider's gaze" on the families: I wanted an intimate view of their lives. I think this was the beginning of articulating my childhood dream of becoming a photographer.

I began teaching photography in my late teens in North Philadelphia. I later moved to Brooklyn and worked for the Neighborhood Youth Corps Photography program in Ocean Hill-Brownsville. It was the summer of 1969 and my first year in New York City as a young photographer. I entered Brooklyn as a young black woman sporting an Afro,

ready to photograph and teach in the neighborhood. Wide-eyed on a mission and naïve about the politics of the community leaders, I found myself in the midst of the decentralization of the public school system, political uprisings, and the aftermath of the 1968 riots.

I was excited about the possibilities of photography, but attempting to devise a lesson plan was not an easy task while political issues were in the forefront of the neighborhood town meetings and weekly staff meetings. What I remember most about that experience was going to the Metropolitan Museum of Art to view the exhibition, *Harlem on My Mind,* and during the same period hearing the young children on the streets of Harlem and Brooklyn saying to me, "Hey miss, take my picture." I often complied with a quick click of the shutter of my 35mm Minolta.

As I attempted to enter my students' lives through photography and my daily lesson plans, I found it difficult to reach their parents who often resisted what they viewed as my "college student" intrusion into their community. I wanted the students to photograph in their homes, playgrounds, neighborhood stores, and churches, and on the "famous" brownstone stoops. They wanted to photograph each other posing and/or mugging for the camera. Their parents wanted them to photograph only the "positive" images in the community. The struggle was on-going for the first four weeks. After a month of teaching darkroom techniques, I also found it important to teach the students how to talk about what they experienced while photographing. To that end, I asked them to keep a diary to write about the photographs they printed and about the pleasures and difficulties in making the photograph.

What I learned from this experience was that these young people had a voice and understood how to deconstruct their home life in provocative ways. They knew joy, sorrow, and loss. They talked about large families, grandmothers and grandfathers, mothers and fathers, big brothers and sisters, and about the babies in their families. By looking at their photographs and talking about making them, they began to realize that their lives had importance and their photographs illustrated that their com-

munity was broader than what was depicted in the daily presses—often images or stories of crime, welfare, and the struggle for equal education.

Over the years, I have thought about this experience and my own life as an artist and wondered how and why I maintained my interest in the "visual." Was it because of my mother's beauty shop and how she transformed the women in our community; was it because of my father's avocation, or was it the experience of discovering the works of Roy DeCarava and Langston Hughes?

My career has been divided into two distinct areas—studio art and art history. My academic writing has addressed critical questions in the broad areas of photographic history, visual culture, African American art, and popular and material culture. Within these fields, I have consistently focused my research on themes such as body politics, race and gender, African American photographers, and the politics of visual culture. I selected these topics because they involve central questions of visual theory and art history practices. For example, as a practicing professional and educator, I noticed that there has been no text offering a critical discussion of the photograph referencing the black subject or the African American maker of the photograph.

My central questions broadened over the years as I began to think critically about this gap in the histories and later I produced books and published articles addressing images of black subjects. I looked at how photographs have been used by art photographers looking at the family, how families and the general public preserve images, the implications of stereotyping, how gender is portrayed, and what assumptions are made of images of women. Most of the essays here offer new interpretations of the generic photographic history, African American art, and gender studies. My essays seek to recover photographers whose works have been overlooked. I also examine the works of contemporary photographers who create imagery focusing on identity and family experiences.

Picturing Us: African American Identity in Photography

O
ne day in June 1992, I talked at length with the writer and cultural critic bell hooks about her recently published book *Black Looks: Race and Representation* and discovered that we were both transfixed by the same image, a portrait of Billie Holiday made by *Ebony* and *Jet* photographer Moneta Sleet, Jr. We both felt moved by the subtlety of the image in displaying the sensitive, sensual nature of the subject. We talked for a long time about why it was so important that we think and write critically about images and how they affect the African American community.

That same evening, another friend, Kathe Sandler, called to tell me that she had finished editing her film, *A Question of Color*. To promote the film, she told me she was using a photograph of "newly freed slaves" that I had found in 1972 in the Philadelphia Public Library. The following day, Clarissa Sligh invited me to come to her opening in Washington, D.C., at the Washington Project for the Arts. The exhibition was a political art installation entitled *Witness to Dissent: Remembrance and Struggle* with photographs, text, and video installation recounting her involvement in the civil rights movement. She had also invited over 200 people to write about "how the civil rights movement affected their lives," and their statements were included in the installation. I talked with her about a scrapbook in the exhibition that included snapshots and newspaper photographs of her as a teenager when she had been a plaintiff in a suit to integrate the public schools of Arlington, Virginia. We talked specifically about the newspaper photograph and how her family preserved the image and what it meant to her today, over 30 years later.

These three conversations made me wonder why there has been no text offering a critical discussion of the photograph, or the maker of the

photograph, in the African American community. We have all looked at photographs of Africans and African Americans. In looking through picture books, photograph collections, and private albums, I have encountered many intriguing and disturbing images. The photographic medium has given me the opportunity to walk through history and imagine the lives of distinct peoples.

PHOTOGRAPHY AND IDENTITY

The photographing of African Americans for personal collections, scientific studies, advertising purposes, or for general public use dates back to 1839. Early black-and-white photographs taken by artistic photographers attracted the attention of a buying public. Some photographers created images, specifically made for private collections, that idealized family life and notable individuals. Other photographers found it more profitable to create a series of prejudicial and shocking photographs of their black subjects, provoking critical comments, favorable as well as adverse, from various communities. Many of these photographs were negative, insulting images of black Americans—such as young black boys used as "alligator bait," and old, grinning black men eating watermelon. Today, such 19th century genre subjects, including various poses of African American men, women, and children, have enjoyed more popularity with collectors and the general public than many other images made during that century. Many of these images of blacks are rare and salable to dealers, auctioneers, collectors, and curators. Ironically, some of the most impressive and startling photographs of blacks were also produced in the 19th century.

In the last few years, there has been a surge in interest in photography, specifically in the ways one looks at and interprets photographs and how identity and representation are constructed in photographs of African Americans. I have spent many hours thinking about photography, criticism, and how the photographic image has transformed my life. Very early on in my process, one thing became very clear: Despite the

162

long history of critical writings on photography, there is a lack of books and articles on reading photographic images of and by African Americans. As bell hooks has written in her book *Black Looks*:

> *Like that photographic portrait of Billie Holiday by Moneta Sleet I love so much, the one where, instead of a glamorized image of stardom, we are invited to see her in a posture of thoughtful reflection, her arms bruised by tracks, delicate scars on her face, and that sad faraway look in her eyes. When I face this image, this black look, something in me is shattered. I have to pick up the bits and pieces of myself and start all over again—transformed by the image.*

I have chosen several photographs and photo stories to reconstruct here. My hope is to present the variety of photographs that played a part in shaping my interests in photography—that is, in history and identity.

THE SWEETFLYPAPER OF LIFE

I was seven years old when my mother decided that she wanted to be a beautician and enrolled in the Apex Beauty School on South Broad Street in Philadelphia. The year was 1955 and my mom had three daughters, four sisters, four aunts, nieces, a mother, and grandmother. All of them supported her interest in becoming a hairdresser. Still, a few were a little skeptical when Mom wanted to put a hot comb to their roots. Her daughters, however, had no choice; we had to experience that rite of passage.

It was also in 1955 that Langston Hughes and Roy DeCarava published *The Sweetflypaper of Life*. This book described life in Harlem through the eyes of a grandmother, Sister Mary Bradley. Every week, my older sister and I went to the public library on Lehigh Avenue to select a book to read for the week. That was a ritual we had performed since we started elementary school. I can still remember browsing the shelves, looking for an easy-reading book that I could finish in time to go to the Saturday matinee. On one occasion, I stumbled upon *The*

Sweetflypaper of Life and proudly brought it home. DeCarava's photographs left an indelible mark on my mind. Hughes was already a household name because of the books my father had in his bedroom and, of course, during Negro History Week, we always read his poetry.

As I struggled through the book, I was excited to see the photographs. It was the first book I had ever seen with "colored" people in it—people that I recognized, people that reminded me of my own family. I remember looking at it in the "kitchen," the upstairs room where my mom "did hair," waiting my turn to get my hair straightened, which I dreaded. The wait was always filled with listening to my sister or my cousin crying and watching them pull away in pain from the hot comb.

First, I read the book visually, "reading" the pictures and relating them to the experiences that I imagined Langston Hughes was writing about. I could read words only with some difficulty, but I was learning to read images with ease and imagination. Then, as I waited, I began to read and understand the text. I looked through the pages with great intensity, asking questions about the people. The lighting in the photographs was dramatically dark and realistic. The stories told in the pictures were simple for me to understand, the photographs spoke to me in a manner that I will never forget, and they led me to ask questions about the photographs we had in our house.

The images on the wall, on the mantel, and on the piano were taken by my father's cousin, Alphonso Willis. He was the family photographer and had a commercial studio near our house. My father was a serious amateur photographer himself. He had a camera that always fascinated me. I was unable to use it because it was too difficult for me to hold, and I had trouble focusing on the ground glass, but I always looked forward to my father coming home with the past week's prints and negatives. I enjoyed placing the photographs in the photo album and trying to structure the album the way Hughes and DeCarava had set the photographs in *Sweetflypaper*.

In *Sweetflypaper*, Hughes and DeCarava spoke of pride in the African American family, good times and hard times, with an emphasis on work

164

and on under-employment. *Sweetflypaper* said to me that there was a place for black people's stories. Their ordinary stories were alive and important and to be cherished. There were photographs of black women in tight sweaters dancing sensually, just like in the movies of Marilyn Monroe, sassy women and women who sacrificed for the family; and then there was Rodney, photographed handsomely by DeCarava in lighting only he could capture. For me, a veil was lifted. I made it

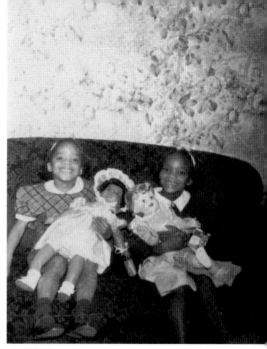

Untitled Snapshot of My Sister Yvonne and Me, 1955
Thomas Willis

a point from that day on to continue to look for books that were about black people and to look at photographs that told or reflected our stories.

MY SISTER YVONNE AND ME

This photograph was taken the day after Christmas. My father and his cousin were always on hand to commemorate special family occasions like graduations, weddings, family reunions, and funerals, as well as everyday events. I found this picture in an album while compiling family photographs to use in a photo quilt. Here, my sister and I are two pretty little girls holding our brand-new Christmas presents. Our smiles are wide as we sit before the camera. I am on the left, holding the black, brown-eyed, black-haired doll, and my sister is cradling the white, blue-eyed, blond doll. Our features indicate that we are sisters, and the external clues about our choice of dolls create a curious narrative.

When I look at this image today, I think of the Dolls Test, devised by black psychologists Kenneth and Mamie Clark. In an attempt to investigate the development of racial identification and preference in African

gate the development of racial identification and preference in African American children, the Clarks performed a test in which black children were asked to select a white or black doll to play with. Results of the test showed that the black children, ranging in ages from five to seven, clearly rejected the brown-colored doll, preferring, by and large, the white one. The test asked the black children to select the doll that was most like them. Other directions included:

- Give me the doll that you like to play with, or the doll you like best.
- Give me the doll that is the nice doll.
- Give me the doll that looks bad.
- Give me the doll that is a nice color.

In looking at this snapshot of my sister and me, I find it a real-life, personal illustration of this test. I wonder now when I became aware of racial identification in toys. Learning about race and racial pride was encouraged by the black teachers I had in elementary school. Many of my friends who were educated in the North did not have black teachers. I was fortunate because at home and at school, racial pride was taught. I called my mother recently to ask why, in all the photographs, my dolls were black and Yvonne's were white. She told me about how she and my father would take us Christmas shopping and how I insisted on having black dolls. She said my sister rejected them until we were too old to buy dolls. This photograph offers insight into my early interest in understanding African American material culture.

One of the memorable photographic "moments" for me was in 1969 when I visited the Metropolitan Museum of Art's exhibition, *Harlem on My Mind*. It was the first experience I had in a major museum where photographs of African Americans were presented. I had recently moved to New York City from Philadelphia with my cousin Veanie to take photography classes, and I visited virtually every museum in the five boroughs of New York City. There was an audio component to the show so

walking through the grand galleries of the Met, I heard jazz, blues, and speeches. I heard the anonymous voices of the community and the familiar words of Malcolm X. There were small photographs and photographic murals, photographs mounted on Masonite and images blown up to 50 feet, and all of them of black people including Reverend Adam Clayton Powell, Sr.; the Sunday school classes at the Abyssinian Baptist Church; Paul Robeson; Marcus Garvey; and Madame C. J. Walker.

I vividly recall walking through the exhibition wondering why protestors on the front steps were carrying placards saying, "Whitey Has Harlem on His Mind—We Have Africa on Our Mind." At the age of 21 and never having seen images of black people exhibited in a major museum, I felt great pride in that presentation at the Metropolitan Museum of Art in New York City. But I also felt conflicted. I wanted to discuss my pride in the exhibition openly with the people I met on the picket line, but was afraid to do so because of their obvious discontentment.

I later heard the issues voiced this way: Why were photography and social issues being examined in an art museum? Why were there no black artists on the curatorial advisory committee? And the title of the exhibition, *Harlem on My Mind*, was taken from an Irving Berlin song! I wanted to honor the picket line, but I also wanted to experience the photographs. I went back five times to view that groundbreaking show.

JAMES VANDERZEE

I was most curious about the photographs of James VanDerZee and wondered who he was and why he was not mentioned in any of my books on the history of photography. One image in particular, *Raccoon Couple in Car*, raised a whirlwind of social and photographic questions. Just as *The Sweetflypaper of Life* had prompted my general interest in photography and African American images, confronting VanDerZee's photograph marked the beginning of my formal education in the field of photography. *Raccoon Couple* perfectly symbolized, in my mind, the celebration of black life and economic and cultural achievement.

In the photograph, the car is parked away from the curb, the woman is wearing a full-length raccoon coat, as is the man. He is partly seated in the car on the passenger's side and she is standing in the street. As I looked at VanDerZee's portrayal of this couple, it was easy to romanticize this period in Harlem's history, known as the Harlem Renaissance. In the stories I heard about while I was growing up, Harlem was a source of pride. The long stories told by my parents, aunts, uncles, and their friends could keep me spellbound for hours, all about the dances, the rent parties, the plays, and the musicians. VanDerZee empowered his subjects for posterity. During that period, Harlem, like the rest of the country, was struggling to survive during the Depression years. His photographs broke the stereotype of Harlem during the Depression, and seeing the exhibition in 1969 made me want to recover the personalities captured within his frame. The couple appears to be distant, yet charming. There is a sense of spontaneity. There is a wonderful play of reflected light and distorted image in the chrome of the wide spare wheel. I imagined, as I saw this photograph on the walls of the Met, that life during the Harlem Renaissance must have been vibrant, supportive, and full of pride. At the same time, I wondered about the newly arrived migrants from the Deep South? Where were they? Were they invisible to VanDerZee?

MALCOM X

This image of Malcolm X with his family is composed of the typical elements found in family photographs: father, mother, and children. When I first saw it, I noticed how the positioning of the family was in stark contrast to that in my own family photographs. Malcolm X stands to the right of the frame, while his wife, Betty Shabazz, sits on the sofa with one of her daughters on her lap. The other daughter, Attallah, sits at her mother's side looking into the camera, her index finger in her mouth. The room is decorated simply and the plainness of the room heightens the drama of the image. A portrait of the Honorable Elijah Muhammad is perched high on the wall, at the line of the molding, as if

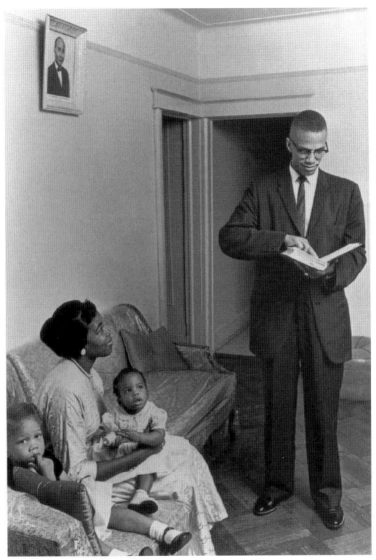

Malcolm X with Wife Betty Shabazz and Daughters, c. 1959
Richard Saunders

he is looking over and approving this domestic scene. It is an unusual height for a framed photograph. It was clearly a conscious act to place the photograph in that manner.

As I studied this photograph over the years, I began to feel as if I

were an invited guest in their living room. As I "read" this photograph of Malcolm X and his family, the image becomes more than a family affair; it is also a political statement. Malcolm X is seen here as the husband and father. His wife, Betty Shabazz, is smiling quietly and looking admiringly at her husband as he appears to be reading a book. Is he reading the Koran or is it just a prop for the photographer? The floors are shiny and there are plastic slipcovers on the sofa, of the sort commonly seen on furniture in the late fifties and early sixties in middle-class homes in this country. The family looks lost and out of place in the scantily furnished room which seems stripped of familiar and familial objects. Without these objects, the family seems to have less of an identity. The portrait of the Honorable Elijah Muhammad appears to be the most treasured and essential artifact the family possesses. Looking at this image, one assumes that the family is obeying a religious stricture not to covet "worldly possessions."

We often learn from photographs how a family has lived. Malcolm X was a public figure, and very few of his personal photographs have been published. What I find intriguing about this photograph is the fact that the conventional public image we have of him is still preserved here: he is dressed in a suit, his furniture looks uncomfortable, and it appears that he has no time off. Indeed, in 1990, I received a call from Malcolm X's daughter Attallah asking me for a copy of this photograph which had recently appeared in a book I edited, *An Illustrated Bio-Bibliography of Black Photographers, 1940-1988*. She said the family did not have many photographs of private moments.

THE EXECUTION OF WILLIAM BIGGERSTAFF

The first time I saw this picture was in 1972 when it fell out of a pile of photographs sent to me from the Montana Historical Society. I was researching a paper on black photographers while an undergraduate at the Philadelphia College of Art. My search for black photographers was an attempt to respond to the proliferation of negative, derogatory

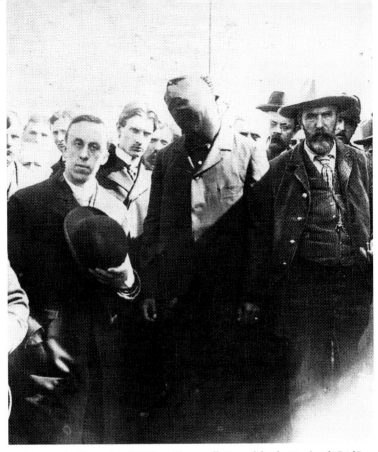

Photograph of Execution of William Biggerstaff, Hanged for the Murder of "Dick" Johnson, April, 1896, Helena, Montana, with Rev. Victor Day, J. Henry Jurgens, Sheriff, 1896

J. P. Ball (Courtesy Montana Historical Society)

images of black people. White perceptions of black inferiority were often reinforced by the images of black men that I had seen as well, and my intention was to challenge those images and the history books by identifying the breadth and depth of experiences of black people as recorded in photographs.

This image was one of a set of four. One was taken in the studio while William Biggerstaff was still alive; the others were taken during and after his death. I was surprised to learn that the photographer, J.P. Ball, was a black man. I later learned more about Ball, but upon my first viewing of this photograph, I studied it for a long time and won-

dered, given the history of lynchings of black men in America, how he could have photographed another brother being hanged?

An inscription on the verso read:

William Biggerstaff, a former slave, was born in Lexington, Kentucky, in 1854. He was convicted of killing Dick Johnson after an argument that took place June 9, 1895. Biggerstaff pleaded self-defense. The records state that after postponement, the hanging took place April 6, 1896; the 'weight fell at 10:08 A.M. in Helena courtyard.'

It was difficult to express my feelings when I first saw this photograph. I could see a ring, possibly a wedding band, on Biggerstaff's limp left hand. I tried to imagine Biggerstaff's life: born into slavery, migrating to the West in the hope of contributing to its expansion, possibly marrying and having a family, dying at the age of 42. After surviving slavery, having spent the first eleven years of his life as human property, Biggerstaff's final portrait is that of a man silenced. He can no longer defend himself or express his anger. He must accept his violent death with dignity. He is dressed in a suit and tie. A tie-pin is positioned neatly on his chest and the top button of his jacket is still fastened. Yet, seeing his neck broken, even though the hangman's hood still covers his face, we know that his body is lifeless. The white men who witnessed this hanging stand proud. One rests his bowler hat on his chest, others look directly into the camera, without emotion.

What about the other black man in this picture, the one behind the camera? Is he only the recorder of this "legal lynching," or is he sending us another message? His photographic legacy has revealed a disturbing story, and one that has been suppressed. Recording this execution must have been an unsettling experience for Ball, who I later learned had been an abolitionist. He knew that black oppression was often violently manifested in the lynchings that Ida B. Wells and others protested against, but which continue to this day.

TROUBLE AHEAD

The photographer Christian Walker gave me a set of late-19th century lantern slides for my 42nd birthday. He knew of my interest in collecting black images from this period. These photographically beautiful and well-preserved glass slides are examples of a genre commonly known as "Black Americana," which includes a wide variety of popular artifacts depicting crude, degrading, racial caricatures of African Americans.

This sequential lantern-slide set depicts a weary-looking African American woman in a printed dress and white apron. There is a floured rolling pin on the table, and her gesture suggests that she is rolling dough and making bread, possibly as a means of self-employment. The image clearly establishes her class position. A small child lies beside her, asleep in a wooden cart. Behind her, an older male child, about eight years old, is scribbling on the wallpaper. The drawing made by the child might be a drawing of the mother, because the word scrawled on the wall over it is "Mamy."

In the second slide, she has placed the "unruly" older child across her knee and is spanking him. This slide, which glorifies the beating of a young African American male, was produced for

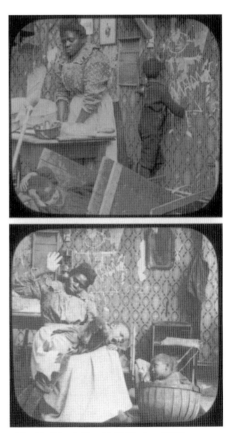

Trouble Ahead, Trouble Behind, c. 1880s
Keystone View Co.

173

the amusement of a white audience, as were others, such as the postcard images of young African American boys depicted as "alligator bait." The image of a young black man being spanked by his mother is undeniably a destructive one that plays on stereotypes and perpetuates racial myths. These images now exist as frozen racial metaphors from a time when images of African Americans were rarely produced by or for African Americans, but rather for the "amusement" of a white audience.

In an article entitled "A Tribute to the Negro" (published April 7, 1849, in the journal *The North Star*), Frederick Douglass cogently explains the problem inherent in attempts by white artists in the 19th century to depict likenesses of black people:

> *Negroes can never have impartial portraits at the hands of white artists. It seems to us next to impossible for white men to take likenesses of black men, without most grossly exaggerating their distinctive feature. And the reason is obvious. Artists, like all other white persons, have adopted a theory dissecting the distinctive features of Negro physiognomy.*

Upon reflection, this quote seems to adequately summarize the depiction of black people worldwide, and it remains true for this century also.

"ANTHROPOLIGICAL" STUDIES

Black women, in particular, have been subjugated and misinterpreted in photography since the early days of the medium. This is true both in domestic treatments, such as *Trouble Ahead, Trouble Behind*, and in their representation as "exotic" others. The "civilized" photographer-traveler often found the nude image of an African woman irresistible. This 19th century photograph of an African woman typifies what bell hooks calls the "miscegenated gaze." European photographers and tourists were keen voyeurs of African people, and women in particular.

I have found countless nude photographs of African women. From 1839 to well into the 20th century, photographers roamed the continent

making such images. In looking at them, one sees that the face was an unimportant element of the picture. Her buttocks and breasts are the primary focus. Nicolas Monti, traced the history of these images. In *Africa Then: Photographs 1840-1918*, he states:

> One *might almost say that the black woman was imagined without a head. The body is all that counts, a body offered to man's pleasure, an extremely simplified idea in which beauty is exclusively seen as underlining the erogenous zones of breasts and buttocks. The curves are abundant, the back is sumptuous, and the hips are magnificently shaped, while adolescent breasts blossom out on a superb, enticing bust.*[1]

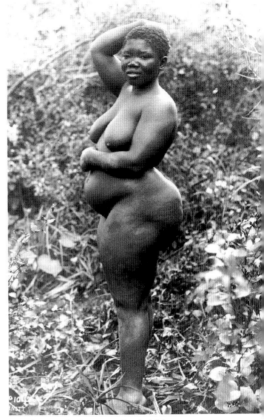

Photograph of Woman, South Africa,
c. 1880s
Barnett

One of the early accounts of this type of image is the story of Saartjie (Sarah) Baartman, also known as the "Hottentot Venus." Baartman was brought to Europe and placed on exhibit by scientists who found the size of her buttocks "grotesque and different." Beginning in 1810, she was exhibited, naked, in cages in Paris and London for over five years. Occasionally, she and other African women like the one photographed here, were the object of amusement at parties in Paris, where they were required to wear skimpy garments. The "Hottentot Venus" was "admired" and depicted as animal-like, exotic, different, deviant. In the Sander Gilman essay in *Race, Writing, and Difference* edited by Henry Louis Gates, Gilman writes:

It is important to note that Sarah Baartman was exhibited not to show her genitalia but rather to present another anomaly which the European audience...found riveting. This was the steatopygia, or protruding buttocks. The figure of Sarah Baartman was reduced to her sexual parts. The audience which had paid to see her buttocks and had fantasized about the uniqueness of her genitalia when she was alive could, after her death and dissection, examine both.[2]

Seeing this photograph and other 19th century images of African women suggests the need for us to clarify and reexamine the discourse of sexuality that still prevails in 20th century images. These "anthropological" studies from the 19th century can easily be linked to advertising and other media today where the African American woman is seen as "Other."

WHIPPING POST

Initially this photograph annoyed me. I was struck by the stiff poses the men in the photograph assumed in order to demonstrate the techniques of torture. Then the photo disturbed me. Three black men, "models" for the photographer, are held in constraining devices; two white men stand on either side of the post, ready for action, and one holds a whip. This photograph acts as evidence of the brutality endured by our ancestors. Why was this photograph taken? Was it meant to show the brutality of enslavement?

I have read, during my entire adult life, about the brutal beatings that black men, women, and children endured during slavery at the whipping post. It was not until I visited the Maryland Historical Society in 1991 that I began to comprehend fully the craft and industry of punishment. I saw a whipping post in an installation curated by Fred Wilson entitled *Mining the Museum*. The cherry-wood whipping post was displayed in the same room with three or four chairs carved out of the same beautiful wood. The ironic juxtaposition of these items was the artist's comment that the same meticulous care and craftsmanship went into both the chairs and the whipping post. The chairs had long been

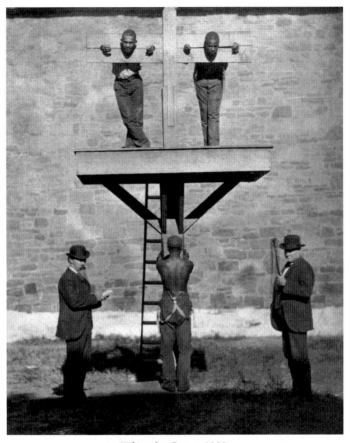

Whipped at Post, c. 1880s
Unknown
(Courtesy of Derrick Joshua Beard)

displayed by the Maryland Historical Society as examples of historical craftsmanship. Fred Wilson found the whipping post in the basement.

The questions raised by Wilson came to mind while I was looking at this photograph. Trying to reconstruct the life experiences of slave culture, I wondered: Who made this whipping post? Why did he place a crucifix-type structure on the platform that was to be used to restrain and torture a black man or woman? What was the purpose of this photograph? And who were the "models"? Were they paid? To question this image is of primary importance when trying to reconstruct the life experiences of slave culture and its legacy.

By renaming this photograph *But Some of Us Are Brave* (the subtitle of a book by Gloria Hull, Patricia Bell Scott, and Barbara Smith), I was allowed to consider how the black men and women themselves responded to this type of punishment and the challenges they endured. It also helped me to imagine the psyche of an individual who could design a torture device in order to control another human being. Since the whipping post in this photograph is in what appears to be a courtyard, I also react to this torture as public spectacle, performed in full view of the townspeople. Other slaves were also required to witness floggings, which were administered by whites as well as by African Americans who were often forced to participate as a means of terrorizing them into obedience.

Perplexed after seeing the photograph and the whipping post in Fred Wilson's exhibition, I began to document in my daybooks various references to flogging:

On the 28th of May 1866, Henry Seward made an affidavit that in December 1861 while in conversation with Mr. Samuel Cox living five miles South of Port Tobacco (Maryland), he confessed that in August 1861, he had murdered one of his Slaves, Jack Scroggins, by whipping him to death...This statement is corroborated by affidavits made by John Sims and William Jackson who testify that Scroggins was flogged to death for having escaped to the Federal lines, when he was recaptured and on the 12th of May 1866. William Hill, an employee at the Senate Post Office, reports this case and states that in whipping Scroggins to death Cox was assisted by Frank Roly, his overseer, and two other men. All these parties are living now at the same place and have never been arrested....

Another man reports his wife's and mother's beatings:

...they were both taken to the barn and severely whipped. Their clothes were raised and tied over their heads to keep their screams from disturbing the neighborhood and they were tied up and whipped very severely and then taken to Upper Marlborough to jail....

178

Flogging is deviant behavior. In order to begin to develop a framework in which to analyze the slave culture, we need to re-examine all participants involved in this photograph: the "models," the artisan, the photographer, as well as the person who commissioned this photograph.

NOBODY KNOWS MY NAME

This daguerreotype is one of the earliest photographic images to refute the stereotype of the black women who became known as "mammies." Many young black women assumed the role of nanny, or "mammy," for white children. The young African woman in this portrait looks pensively into the camera while holding tightly to the child. The woman's head is wrapped in a scarf and tied in the manner of West African women's headdresses. Other than the color of her skin, the headdress is the only signifier of her African heritage. Her mood is solemn, her mouth is closed tightly, creating a sad or resigned look on her face. It is clear that she is a teenager, possibly between the ages of 13 and 15. The young child appears unaware of the photographer as she looks off to the right.

Why was this photograph commissioned? The photograph was taken during the period of slavery, so we can assume that the young black woman is human property. What was the purpose of this photograph? Are the woman and child the "master's" possessions? Or is the black woman the subject or object of the photograph? Because of the complacent expression on the young African woman's face, it is unlikely that this photograph was used for propaganda purposes in the antislavery movement. In asking these questions, I begin to answer them with more conjecture. Did her family ever see this image? If so, what did they make of her situation? Does she live with or near her biological family? The loneliness expressed in her eyes speaks to me 150 years later. It evokes for me the title of James Baldwin's book *Nobody Knows My Name*.

Moreover, this image represents to me the women who wrote of their own experiences in slavery, but were never photographed. There is a self-consciousness depicted in the photograph. As the woman holds tightly

179

to the baby's hand, her eyes speak of a sense of loss—loss of self and identity. It is curious that this image became commonly known in the mid-1980s when it was reproduced as a postcard. Perhaps the image speaks to African American women even today who feel that they, too, could lose their individuality at an early age. Fifty years after this photograph was taken, the poet Paul Laurence Dunbar wrote these words in his poem "We Wear the Mask":

We wear the mask that grins and lies.
It hides our cheeks and shades our eyes,
This debt we pay to human guile:
With torn and bleeding hearts we smile,
And mouth with myriad subtleties.

Women's Stories/Women's Photographies

Nineteenth-century photographic self-portraiture represented the self in mirror-like images of the face. In the 20th century, self-portraiture branched into several different modes of thought and presentation, its forms driven by analysis and revelation. Among the artists working in the genre today are photographers who have expanded on the historical meaning of portraiture by turning the camera on their own bodies, as well as by turning the page of the family photo album, thus creating a document about themselves and society. In effect, these photographers become storytellers using photobiography as their medium.

This essay considers the work of four photoartists—Fay Fairbrother, Clarissa Sligh, Margaret Stratton, and Carla Williams. Notable photobiographers, they use appropriation, multiple-printing techniques, fabric, unmanipulated images, and manipulated photographs to make compelling visual statements about contemporary multiethnic society. Their pictures are made, not taken. Developing themes related to gender, family, race, difference, and stereotyping, the artists explore the implications of historical and contemporary images of women, and explore new approaches to representing the personal through visual work.

All four artists are concerned with issues of gender and identity. While their family structures differ, the stories they create are similar and are constructed with familiar descriptive captions. Here I explore their individual perspectives and their common ideological concerns.

CARLA WILLIAMS

Los Angeles-born artist Carla Williams juxtaposes 19th century images and texts on racial differentiation with strikingly naked self-portraits. Based on the science of phrenology—which advanced the idea that the

conformation of the skull indicated mental faculties and character traits—the images provide a harsh set of historical observations, some of which led to contemporary racist theories. In the series entitled *How to Read Character*, Williams used the phrenological text as labels for her self-portraits, which include head shots and profiles of the head and torso; the text is incorporated into the images. One label, for example, reads "if cortex of the Negro brain is thinner, it must contain less cells and his brain must be inferior to that of a white person."

Williams' images encapsulate the experiences of black women across the centuries. Historically, the black woman's sexuality has been shaped by racist assertions that blacks were inferior and sexual deviants. Black women have been subjected to racist theoretical studies and physical exploitation. Sander Gilman's "Black Bodies, White Bodies: Toward an Inconography of Female Sexuality in Late Nineteenth Century Art, Medicine, and Literature" is a wrenching account of what Saartjie (Sarah) Baartman experienced. This African woman was often exhibited at parties in Paris, scantily dressed to provide amusement for the guests. In Paris and London for five years she was caged and displayed naked to a public that paid to view her body, specifically her buttocks. bell hooks asserts:

> They {were} not to look at her as a whole human being. They {were} to notice only certain parts. Objectified in a manner similar to that of black female slaves who stood on auction blocks while owners and overseers described their important, salable parts, the black women whose naked bodies were displayed for whites at social functions had no presence. They were reduced to mere spectacle...{T}heir body parts were offered as evidence to support racist notions that black people were more akin to animals than other humans.

Inspired by the numerous critiques of Baartman's exploitation, Williams began to reference her own body to Baartman's experience in the 19th century. Williams uses her self-portraits to demonstrate that these notions still persist in images of contemporary African American

women. She explains how racist theory is examined in her work:

*Through juxtaposition of 19th century images and text on racial differentia-
tion and categorization with contemporary self-portraits, I hope to suggest to
the viewer that such precedence, while seeming absurd and outdated, still con-
tains a great deal of resonance and power with respect to the way that we
read and respond to contemporary images of African American women.*

MARGARET STRATTON

Margaret Stratton, a Chicago-based artist, examines the social-behavioral
patterns of the middle-class American family, using her own family to
show how women, especially mothers and daughters, collect, wear, use,
preserve, and display personal and household objects. She provides us
with a biographical record of a way of life, a particular era, and a story
about self. The bonds that tie us to time and to family members are the
underlying theme of her series *Inventory of My Mother's House*. Stratton
becomes the voyeur in her mother's house, and links her mother's pat-
terns of consumption to those of women in general. Her mother's house,
sprinkled with artifacts from Western culture, becomes a signifier of
femininity and domesticity, and Stratton's mother herself, now deceased,
lives in her daughter's memory because of these objects. Viewing this
work, we bring to it our own personal experiences, our knowledge of
childhood and shared family memorabilia. Stratton affirms who we are
and where we have been. She prompts us to reexamine, restage, and
scrutinize our family and familial traditions. Her ordering and rearrang-
ing of the objects undermines the viewer's sense of how they are usually
placed and their ordinary utility. Their presentation, neither romantic
nor vain, is a record of humanity which celebrates the ordinary and
acknowledges humility.

Inventory of My Mother's House is a photographic installation of 190
photographs of objects in her parents' house. She has this to say about
her work:

Inventory of my Mother's House
Margaret Stratton

As a group, these photographs reflect the good life as well as the ease with which they slide into obsolescence—a treasure hunt of post-industrial kitsch. These images also testify that what mass production has given us is an efflu-via of products with either little or questionable value—things for their own sake—objects whose function is emotional rather than physical. Mantles of collectibles and statuary that stand for the 'authentic' house is a true post-modern space, an organic and unintentional evolution from necessity or orna-ment, that mirrors both their economic status and the robust wealth of an economy inclined toward the production of trifles. Within its four walls, all eras and styles are represented with equal weight. Nothing is more important than anything else so nothing can be, or ever is, thrown away.

CLARISSA SLIGH

Clarissa Sligh writes:

As the first girl and third child of six children, I had no competition being the keeper of our family photograph album. Snapshots were tucked in drawers all over the house. I collected and put them together. I found, in somebody's trash a big, heavy book that had been used for Christmas card samples. Before pasting the photographs down, I spent weeks arranging and rearranging the pictures to compose a story about my family life.

Sligh's work is layered with suggestive messages and conveys her enlightened and haunting personal experiences. It also focuses on the exploitation of women in the workplace and at home.

Weaving politics with art using family photographs, Sligh directs her audience's gaze to sociological relationships centered on experiences

Reading Dick and Jane with Me
Clarissa Sligh

with the African American community. As the keeper of her family's album of photos and other memorabilia, she is cognizant of the role she plays in preserving her family's history. At the same time, she places herself and her family within a larger picture of American history. In shifting attention away from her personal experiences, she is able to analyze the shared experiences of black children.

In one series entitled *Reading Dick and Jane with Me*, Sligh cogently reconstructs the images of Dick and Jane with snapshots from her family album. The standard American public school Dick and Jane-type readers presented a "typical" American family as well-to-do whites living a relatively trouble-free life (the originals were published from 1935 to 1965).

Reading Dick and Jane with Me is an illustrated reader seen through the eyes of a black woman artist who spent her own childhood growing up poor in the American south of the 1940s and 1950s. It combines lively repetitive words, photographs, and drawings. Sligh "reads" the images of Dick and Jane and inserts words on each page—for example: "You play in your good clothes every page. We must keep our nice for Sunday School Days." She makes us aware of the psychological effect the primary school reader may have had on black children. She allows the invisible black child to be identifiable as well as visible.

As a young Black child, before I could even think, I was told how bad things are out there in the world for us. It was a fear put into me to prepare me for the real world. Since we couldn't talk about it, since no one could relate to our hurt or pain, we learned to be silent, to hide our disappointments, to hide our anger at the distortion of our identity and the exclusion of our reality.

Sligh's work is important not only because she addresses the realities of racism and sexism in a straightforward style, but also because she assembles with exemplary skill ideas and artifacts in a sound, cohesive way.

FAY FAIRBROTHER

Fay Fairbrother also addresses issues of the family—its strengths, fears, failures, and successes. She openly explores repression and racism through the art of quilt-making. Fairbrother's "quilts" entitled *The Shroud Series: Quilt Shroud* include turn-of-the century formal portraits of black and white families, images of black men who were lynched and mutilated, Ku Klux Klan activities, and patterned cloth. The pictures reproduced in her work create a patchwork of events depicting the injustices and privileges of two distinct families—black and white. Fairbrother's research on lynchings of African American men revealed that after men were lynched, they were taken down from the trees and wrapped in quilts for burial. That research led to *The Quilt Shroud*. Discarded cloth fragments are sometimes used to tell a story of an anonymous family. One quilt includes family photographs and activities of the Klu Klux Klan, including the participation of wives and children of Klan members. Fairbrother's use of quilts is a powerful and disarming way of telling these stories. They suggest, but leave unanswered, questions regarding segregation, life and death, and photography's role in depicting ordinary domestic life and racial violence in American life.

Fairbrother comments:

The theme of 'Quilt Shroud I' is the family, with the quilt as a representation of family. The posed studio portraits of black and white families illustrate the sameness of the family group. Posed in their Sunday best, you know the children are taught the same Christian values and morals. But where does the process go wrong with KKK meetings such as the one illustrated on the third row resulting in black men hanging from trees? I have also tried to show the results of the removal of the black man from his family and the wife shown alone in the studio with their child who has been robbed of his father. The quilts are my own design, kept simple in order for the photographs to speak.

Like many of our mothers and grandmothers, Fairbrother's ancestors were quilt-makers. A third generation quilter herself, she learned the tradition from her mother. Fairbrother grew up in a white, middle-class environment in the South. Re-examining the stories she heard from her family about racial violence in her hometown, Fairbrother expands the notion of self-portrait by creating a wider portrait of her community, and she demonstrates how memory helped to shape her art in a social context.

The photoartists whose work is reproduced here respond to the uniqueness of their own lives. Whether they stay within the traditional definition of self-portraiture or contradict it, all generate an emotional message that transcends simple notions of self-representation and re-characterizes photo-autobiography. Their personal art interrogates or overturns social ideas to make powerful statements about race and gender in American culture.

History

Photography and the Harmon Foundation

The first black photographer to have his work shown in a publicized exhibition was Jules Lion. The show was held on March 15, 1840 in the Hall of the St. Charles Museum in New Orleans, "in which shall be seen the likeness of the most remarkable monuments and landscapes existing in New Orleans...all made by means of the Daguerreotype."[1] The daguerreotype, invented by a Frenchman, L.J.M. Daguerre, was the first practical photographic process. The exhibition, organized and sponsored by the artist, was reported to have drawn a large crowd.

In 1854, Glenalvin Goodridge of York, Pennsylvania, won the prize for "best ambrotypes" at the York County Fair.[2] Harry Shephard won first price at the 1891 Minnesota State Fair and later exhibited photographs of the Tuskegee Institute at the Paris Exposition in 1900. Daniel Freeman, reputed to be the first black photographer in Washington, D.C., had his *People and Places* exhibit shown in the Negro Building at the 1895 Atlanta Exposition.

This information a gives historical context to the scant exhibition record of black photographers working in this country prior to the Harmon Awards. Exhibition activity was meager. Shows were held and supported by the photographers themselves, the black community, state and local fairs, as well as annual trade expositions. By the turn of the century, increasing numbers of photographers were learning the art of photography and producing artistically posed images of black subjects as well as genre scenes.

In the 1920s, young black artists moved to the large cities seeking education, patronage, and compatriots in support of their art. Many moved from the Caribbean, the West, and the South to Chicago, Washington, D.C., and New York City. Harlem was a cultural mecca for many of these artists, writers and students. In 1921, the New York

Public Library's 135th Street Branch (now the Schomburg Center for Research in Black Culture) organized its first exhibition of work by black artists, entitled *The Negro Arts Exhibit*. The purpose of the exhibit was to lend encouragement to "those who aspire to artistic expression as well as to give to the public a glimpse of this still undeveloped but very important side of the Negro." Two photographers, C. M. Battey of Tuskegee and Lucy Calloway of New York, showed six photographs in this exhibition of over 65 works of art.

The need for exhibition opportunities did not go unnoticed by the Harmon Foundation, the first philanthropic organization to give attention, cash awards, and exhibition opportunities to black photographers. In 1925, the Foundation announced they would be presenting awards to seven "Negroes of American residence." These awards came to be known as the William E. Harmon Awards for Distinguished Achievement Among Negroes, and were "especially designed to give stimulus to creative work through recognition of achievement of national significance and to bring public attention to persons making such outstanding contributions."[3] Photographers submitted their works in the fine arts category which had a first prize of $400 with a medal, a second prize of $100, and when deemed appropriate, honorable mentions. In 1930, a special prize of $50 for photographic work was added in the name of the Commission on Race Relations.

The Harmon award attracted the attention of photographer James Latimer Allen in the late 1920s. During the 1930s, only four photographers beside Allen applied for these prizes. These photographers were producing work of lasting value, much of it race-conscious and romanticized portraits of dignified black men, women, and children. Only one, King Daniel Ganaway of Chicago, submitted pictorial photographs. The other photographers included New York-based Edgar Eugene Phipps and twin brothers Marvin and Morgan Smith. The Smiths never received an award or exhibition opportunities, though they submitted in two categories, painting and photography.

191

JAMES L. ALLEN

The first Harmon Foundation exhibition to include works by a photographer was held in 1929. Of the 91works in the exhibition, three photographs by James L. Allen received honorable mention: *Motherhood*, *Portrait of a Girl*, and *Portrait of Nella Larsen*.

Allen became the photographer most honored by the Harmon Foundation. Born in New York in 1907, Allen's interest in photography began in grade school. As a member of a camera club, the Amateur Cinema League, Allen attained public recognition at an early age. While a student at the DeWitt Clinton High School, Allen had the unusual advantage of apprenticing with a large and well-known New York photographic firm, Stone, VanDresser and Co., where he—quite possibly the only black employee—received substantial training in portrait and still-life photography.

During the 1920s, there were many camera clubs in the New York area, where members came together to discuss the latest techniques in photography. Allen received his first public recognition in 1927 when a group of young black artists in the New York area gave a small exhibition of their work which received "very favorable press comments."[4] Encouraged by this exposure, Allen submitted an application for the Harmon Award on August 13, 1927. The application stated the candidate's profession as "professional photographer."[5] His sponsor was Wallace Thurman, then a highly acclaimed novelist and journalist. Allen also obtained recommendations from other prominent figures of the era—Langston Hughes, Carl Van Vechten, and Alain Locke—all who gave him glowing reviews in their individual remarks on his application.

Alain Locke wrote, "Mr. Allen seems to have both technical and artistic equipment to become an art photographer. His specialty seems to be portraits: as camera studies they are quite good—his work in this line is distinctly promising."[6] Carl Van Vechten's comment was, "he has evolved a system of printing without retouching which make his work the peer of that of the best workers in this field. He is the first Negro to

192

really make a mark in the field of high class photography."[7] Langston Hughes wrote, "his portraits of Negroes are the finest I have ever seen. He is indeed an artist with the camera. I know of no other photographer in America creating more beautiful studies of Negro types."[8]

Allen submitted the following portraits for consideration by the Foundation in 1927: *J. Rosamond Johnson*, *Aaron Douglas*, *Selma*, *Mischievous Tommy*, and *Miss Innocent*. In subsequent years, his sponsors included other prominent Harlem residents like Bessye J. Bearden, newspaper correspondent and mother of artist Romare Bearden.

Allen described his photographs as "Portraits of Distinction" and created unusual tone and composition without retouching his pictorial studies. In 1928, Langston Hughes summed up Allen's artistry in this manner:

...to him, his work is an art. Through the medium of the camera, and with Negro subjects, he is seeking to achieve beauty. So few photographers know how to capture with the lens the shades and tones of Negro skin colors, and none make of it an art, since the death of the late Mr. Battey. This young man's work will stand comparison with that of any of the best photographers in the country and with racial subjects. I know of none to surpass him. Mr. Allen is helping to support a mother and two sisters, besides attempting to perfect his ability as an artist-photographer. He deserves encouragement. So few of the young Negro artists in any line care about bringing to light the beauties that are peculiarly racial. Most of them want to sing songs written by white people, write poetry as white people write it, paint as the most mediocre white artists paint in old and out-moded traditions. All of our photographers I know of copy the cheapest white commercial styles. None of them care for or are concerned with the capture of racial beauties on their films—no kind of beauty for that matter. Mr. Allen does desire to do this, to capture beauty and to glorify the race.[9]

A significant shift and interest in acknowledging photographs in the fine arts category became apparent in 1930 when an additional award was added to the roster—the Commission Prize for Photographic Work.

This prize was given "in recognition of the cooperation the Commission on Race Relations has rendered in administering the William E. Harmon Awards for Distinguished Achievements Among Negroes."[10] Allen won the first Commission Prize of $50 for photographic work. The 1933 Harmon exhibition also included prizes established "in recognition of the initial inspiration and invaluable help of the Commission on Race Relations and its secretary, Dr. George E. Haynes, not only in developing the whole program of achievement awards, but also in starting the Art Exhibit."[11] James L. Allen again won the Commission on Race Relations Prize of $25 for his photographs in 1931. Allen was included in Harmon Foundations for 1929, 1931, and 1933 and the Harmon-College Art Association traveling exhibition of 1934-35.

In addition to exhibiting with the Foundation, Allen maintained a successful studio on West 121st Street in Harlem, photographing the families as well as the writers and poets in the community. Allen often worked as the Foundation's photographer along with Jules Belcher. A selection of his unusual photographs of artists working in their studios as well as the Harlem Art Workshops classes and reproductions of works of art appear in all the Harmon Foundation catalogues. His photographs also appeared in *Opportunity*, *The Crisis*, and the *Record* during this time. He participated in other exhibitions at the Carnegie Institute, Pittsburgh, in 1928, the Rotherham Salon, London, in 1929-30, the Texas Centennial Exposition, Dallas, in 1936 and the Library of Congress, Washington, D.C., in 1941.

KING DANIEL GANAWAY

In 1928, Alain Locke characterized pictorialist King Daniel Ganaway of Chicago as a "most promising and serious craftsman."[12] Ganaway practiced photography in Chicago from 1914 through the 1930s. His subjects ranged from the crowded waterways of the Chicago River to sentimental portraits of family life that were reminiscent of 18th and 19th century painters. The romantic quality of his photographs, through his

use of light and shade, soft focus and various other pictorial techniques, captured the industrialization of America as a unique metaphor.

Born in 1883 in Murfeesboro, Tennessee, Ganaway's interest in photography developed late in his life. Arriving in Chicago in 1914, he worked as a butler for one of Chicago's wealthiest families and soon thereafter became interested in the art of photography. He was a committed, self-taught student and spent all of his spare time experimenting and visually framing his subjects. "I see pictures and designs in everything...as I am riding on a streetcar, I am constantly watching the changing lights and shadows along the streets. Using the car as a frame, I compose pictures."[13]

Ganaway's work won him admirers. In 1918, he received the first prize in the John Wanamaker Annual Exhibition of photographs in Philadelphia. Recognition of his work in the Chicago community eventually lead to a position with a local newspaper, *The Bee*, where he produced a weekly rotogravure with scenes and events of the Chicago area.

Ganaway exhibited the following works in the Harmon Foundation exhibition of 1930: *The Gardener's Cart, In Tow on Chicago River, The Spirit of Chicago* and *The Spirit of Transportation*. The following year, he exhibited *The Heart of Chicago, Steel Mills at Night, Spirit of the Great Lakes* and *Watering the Team*. The photographer was intrigued with industrial life on the waterfront and equally fascinated with water, massive structures, angles, and elements of mysticism. Ganaway also exhibited in the International Photographic Salon, entitled *A Century of Progress*, at the 1933 world's fair held in Chicago, at the Museum of Science and Industry later that year and, in 1935, at the New Jersey State Museum.

EDGAR EUGENE PHIPPS

Edgar Eugene Phipps exhibited only once with the Harmon Foundation, in 1933. His photographs included portraits and genre scenes, like *Central Park Lane, Harlem Dancer*, and *Ready for School*. Phipps was born in Jamaica in 1887. He became interested in art while attending a military academy at a British garrison in Jamaica. As a junior entry, he

exhibited watercolors in a group show at Buckingham Palace in London. He soon became interested in photography and moved to New York in the mid-1920s and had a studio in the Harlem community for a number of years. There he photographed the people, community, and the entertainers in the local night clubs. He worked as a photographer with the American Art Galleries for five years, doing catalogue work, and as a photo retoucher for noted photographer Arnold Genthe for nine years.

THE HARMON FOUNDATION AND THE COLLEGE ART ASSOCIATION

Annotations by the staff and supporters of the Harmon Foundation provide a clear and concise picture of the use of photographs by the Foundation. Only a few of their exhibitions included art photography as well as documentary photography. In 1933, the Foundation, in conjunction with the Harlem Adult Education Committee, exhibited over 100 works by students of the Harlem Art Workshop at the 135th Street Branch of the New York Public Library. Still photographs and film were shot of the students and their work. In 1934, in collaboration with the Foundation, Hale Woodruff gathered a collection of 15 works of art and 130 photographs which were shown at Atlanta University and later traveled to the State Teachers and Agricultural College in Forsyth, Georgia. Also in 1934, photographs from the Harmon Foundation were exhibited at St. Augustine's College in Raleigh, North Carolina. Several photographs of artwork from the collection were later exhibited at the Washington School in Terre Haute, Indiana.

The Harmon Foundation and the College Art Association joined forces in 1934 to establish a traveling exhibition program. In her foreword to the accompanying brochure, Audrey McMahon commented:

...the College Art Association is happy to participate with the Harmon Foundation in showing this year a circulating exhibition of Negro art, many of the participants in which have at previous times exhibited through the

Association, as well as in important one-man and group shows, and have become internationally known.[14]

James L. Allen had two photographs in this show, *The Dancer Wenfield* and *Mask-Lilian*.

THE HARLEM ART WORKSHOP

The Foundation launched a new program of documenting the achievements of their exhibiting artists in 1934. They produced and distributed a four-reel film entitled A Study of Negro Artists. The purpose of the film was "to interpret the Negro artist through his background and the influences under which he is achieving today. In this way it is hoped, not only to bring about better interracial understanding, but also a better basis for appreciation of art productions by Negroes."[15] The overall character of the film was to examine the difficulties of sustaining a livelihood, gaining employment and education, and developing a black audience for their works. A number of the Harmon artists participated in the film project; James L. Allen was the only photographer. He is featured in the first reel in his studio with a model preparing for a shooting session. Notes from the film script read: "James Latimer Allen goes through the process of making a photograph, from the setting of the camera through the snapping of the subject, the developing and printing, to the final production of the portrait study."[16]

The film is a unique personal record of how black American artists produced, created, and exhibited their works. It is also an unusual and unique record of the patronage, both black and white, received by the artists. Appearing in the film along with Allen were Richmond Barthe, Aaron Douglas, Augusta Savage, Benjamin Spurgeon Kitchen, Malvin Gray Johnson, Georgette Seabrooke, William Artis, Lois Mailou Jones, Palmer Hayden, James Porter, Susie McIver, Charles Alston, Richard W. Lindsey, Hale Woodruff, Pastor Argudin y Pedroso, and Mme. Suzanna Ogunjami. Bibliophile, curator, writer and advisor to the Harmon Foundation, Arthur

A. Schomburg, organized the premiere showing at 135th Street Branch of the New York Public Library on April 23, 1935, as part of a program to stimulate interest in the Harlem Art Workshop.

A POWERFUL MAGNET

The Harmon Foundation's history of promoting black American photographers in not an unqualified success. For the most part, painters and sculptors received the Foundation's primary awards. Photography was used and encouraged by the Foundation to record and document its art collection as well as to promote its activities, while much of the fine art photography by black Americans was overlooked. Perhaps its biggest challenge was in identifying the fine art photographers. Local photographers appeared to have had more opportunities to show than those out of the New York area. Perhaps, the pool of black art photographers and documentary photographers using the camera as a tool for social change was not considered by the proposers, and, hence, the scarcity of applications in the field of photography. The written history of the Foundation's interest in and support of photographers is spread among excerpts from its exhibition catalogues, letters and newspaper clippings, so only creative assumptions can be made by reviewing the Foundation's records.

It is also important to note that the Harmon Foundation's work was the culmination of a movement that was begun by members of the Harlem community during the New Negro period. Yet, achievements made by James L. Allen through his recognition by and employment with the Foundation are undeniable. The Harmon Foundation yielded him opportunities to exhibit and express his art in a way that no other black photographer had in the first hundred years after the invention of photography. The success of the Foundation can be respectfully noted in that it became a major force and powerful magnet in drawing artists from all fields together to offer a collective vision of work produced by the black American artist.

J. P. Ball: Daguerrean and Studio Photographer

Photography as a documentary resource and art form dates back to the 19th century. Almost from the origin of this revolutionary reproductive technique, African Americans have figured prominently in its history—as documentarians, journalists, artists, studio photographers, and subjects. A free man of color, Jules Lion, is credited with introducing the daguerreotype process to the city of New Orleans as early as 1840. During this period, black photographers, like their white counterparts, made significant contributions to preserving aspects of American history and culture through the photographic medium.

While there is a growing awareness in this country and abroad of the major contributions of black American photographers to this 19th century phenomena, very little social and art historical research or critical analysis has been made of major black photographers of this period. For example, we know relatively little about the work of Jules Lion; or Augustus Washington of Hartford, Connecticut; or the Goodridge Brothers of York, Pennsylvania, and Saginaw, Michigan, and how their work compared with that of their peers or with other 19th century photographers.

African Americans began to apply their talents to the art of portrait making in 1840. At that time, the inhumane institution of slavery endured in America and was to survive for another 25 years. Notwithstanding this cruelty, there were already many freed men and women of color who were establishing themselves as professional artists and daguerreotypists. A few African American photographers gained national recognition as they captured the essence of their communities. Throughout the North, South, and the developing West, they photographed celebrated Americans and their families, the common man and woman, freed and enslaved Africans, and newly arrived immigrants as well as slave owners and their descendants in daguerrean studios, homes, and classrooms.

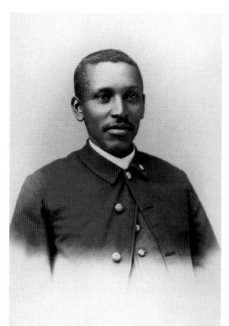

Unidentified Man 957-603
J. P. Ball & Son
(Courtesy Montana Historical Society)

It is astonishing to think about the life and works of James Presley Ball today. Ball was a free black man during slavery, an active abolitionist who created a moving written account of slave life for the sole purpose of lecturing on the brutality of the institution. He was a photographer, an organizer, and a businessman. The extent of his collection is his extraordinary legacy in the development of a medium that captured the expansion of America's West.

Ball's artistic legacy reflects the predominant styles in 19th century American photography, which included stylistic concerns, various photographic techniques, such as daguerreotypes, ambrotypes, tintypes, stereographs, composite printing, hand-coloring as well as sensitive portraits of his subjects. His photographs, whether in private or public collections of the Cincinnati Historical Society, the Cincinnati Art Museum, the Montana Historical Society or the Schomburg Center for Research in Black Culture, convey an uniformity in style and approach that includes intimacy and a conscious effort to express naturalistic poses to interpret the personality of his subjects. The fact that Ball achieved fame and critical acclaim, regionally and nationally in African American publications as well as the photographic and fine art press, is a testament to both his achievements and his undaunted progressive spirit.

This once little-known black photographer made significant strides in the photographic field between 1845 and 1904. In spite of the fact that J. P. Ball's work is in historical societies, libraries, and private collections around the country, the first book about his life and work wasn't

published until 1993. The point of the book was to provide historians, students, collectors, and enthusiasts with a foundation upon which to critique Ball's contributions to the field and place Ball in a context with his contemporaries, such as Matthew Brady, William H. Jackson, and Alexander Gardner, as well as the larger photographic community of the 19th century.

TRAVELING DAGUERRIAN

J. P. Ball was born in Virginia in 1825. His interest in photography began in 1845 after a meeting with John B. Bailey, a black daguerreotypist from Boston. They met at White Sulphur Springs, Virginia, a resort city in the western-most part of the state. Shortly thereafter, in the fall of 1845, Ball, opened a one-room daguerrean studio in Cincinnati, where he spent most of his young adult life. This venture proved unsuccessful. Within three months, he managed to attract only two subjects to create mirrored images, one of whom he photographed on credit.

As did many daguerreans in the early years, Ball closed his one-room studio and worked as an itinerant, traveling from city to city and set-tling for a time in Pittsburgh, Pennsylvania, and later Richmond, Virginia. Many traveling daguerreans set up their cameras in rented rooms, or drove their wagon-studios into town and set up in public areas. He arrived in Richmond in the spring of 1846 with his apparatus (a small trunk, a tripod, a headrest to clamp on the back of a chair, and a few plates) and a single shilling.[1] Having then given that last shilling to a porter, who carried his belongings upon his arrival, Ball found employ-ment in a dining room in a Richmond hotel. Investing part of his mod-est accumulated earnings of $100 in a furnished room near the state capitol building, Ball was able to attract clients to his rented room: "The Virginians rushed in crowds to his room; all classes, white and black, bond and free sought to have their lineaments stamped by the artist who painted with the Sun's rays."[2]

When Ball arrived back in Ohio in 1847, he traveled throughout the

state, continuing to work as an itinerant. He again settled in Cincinnati in 1849, opened a studio and hired his brother Thomas Ball as an operator. Cincinnati was a seedbed of anti-slavery activism, as is evident from Ball's photographs of the citizenry. J. P. Ball received a lot of patronage from the many white abolitionists in the area.

The Ohio underground railroad helped many slaves escape bondage and find freedom in the Great Lakes area and Canada. Harriet Beecher Stowe kept an underground station in Walnut Hills, near Cincinnati, and Levi Coffin, an abolitionist, was also from Cincinnati. Located in a strategic position, neither north nor south, Cincinnati absorbed much of the controversy surrounding slavery. Prior to 1800, fugitive slaves sought refuge in what was then called the Northwest Territory because the laws requiring a runaway slave to be sent back to his owner were seldom enforced there.[3]

GATEWAY TO THE WEST

Ball himself was to publish a powerful anti-slavery pamphlet a few years later. First, however, he put his earlier disappointments behind him and set the goal of having the most successful gallery in the city. Considered by most Americans to be the "Gateway to the West," Cincinnati had a reputation for its culture and prosperous businessmen who emulated their wealthy competitors back East by becoming patrons of the arts.[4]

Ball opened one of the largest galleries in the heart of Cincinnati, "Ball's Great Daguerrean Gallery of the West." The Rinharts noted in their book *The American Daguerreotype* that:

> *Perhaps no other city was more of a focal point for inland daguerreotyping than Cincinnati. Many skilled artists of the camera had settled there, including the pioneers Ezekiel Hawkins and Thomas Faris in 1843, Charles Fontayne in 1846, and the black James P. Ball, who opened a one-room studio in 1847 and, of all the galleries to be established in Cincinnati, the most famous and certainly the most ornate was Ball's Great Daguerrian Gallery*

of the West. Ball's ascent from a small gallery to one of the great galleries of the Midwest makes an excellent example of a successful enterprise far from the eastern centers of daguerreotyping....[5]

Ball also caught the interest and support of a black journalist from the *Rochester Frederick Douglass' Newspaper* who published the following favorable description in an article entitled "The Colored People of Cincinnati":

...We were quite struck with the variety of employments engaged in by colored men in Cincinnati. One of the most credible indications of enterprise, furnished on behalf of our people, is the flourishing business, and magnificent Daguerrean Gallery of Mr. Ball in Cincinnati. We shall treat our readers and friends to a picture of this gallery, with a particular account of it on the first page of our next week's edition. It is one of the best answers to the charge of natural inferiority we have lately met with...[6]

Ball progressed steadily toward mastering the daguerreotype process, using a silver-coated copper plate and making it light-sensitive with iodine fumes, and developing it with mercury vapor, which produced a unique image. Eager to attract clients, Ball published the following advertisement:

"Where do you get your Daguerreotypes?"
"At Ball's."
"Why do you get them there?"
"For four reasons, as follows: His pictures are most lifelike; They are the most beautiful; They are the most durable; And they are the cheapest." Ball's Gallery is at No. 28 West Fourth Street.[7]

Gleason's Pictorial noted Ball's rise to fame in its publication as follows:

> *Mr. Ball employs nine men in superintending and executing the work of the establishment. Each man has his own separate department, and each is perfect in his peculiar branch. We are so well aware of the indomitable industry displayed by the proprietor, that it is no conjecture of ours but our fixed opinion. That it will not be very long before Mr. Ball will be obliged, from the great increase of his business, to have rooms twice as large as he now occupies. His fame has spread, not only over his own but through nearly every State of the Union; and there is scarcely a distinguished stranger that comes to Cincinnati but, if his time permits, seeks the pleasure of Mr. Ball's artistic acquaintance.[8]*

ABOLITIONIST

Not only known as one of the most important image-makers in his community, Ball was also active in the anti-slavery movement. In 1855, he published a pamphlet addressing the horrors of slavery from capture in Africa through middle passage to bondage. This anti-slavery pamphlet and panorama was entitled *Ball's Splendid Mammoth Pictorial Tour of the United States Comprising Views of the African Slave Trade; of Northern and Southern Cities; of Cotton and Sugar Plantations; of the Mississippi, Ohio and Susquehanna Rivers, Niagara Falls, &C*. The publication accompanied the display of a 600-yard panorama that was on exhibit in Ball's gallery. One of the most important 19th century African American landscape painters, Robert S. Duncanson, was attributed as one of the artists who worked on the panorama, according to Guy McElroy, author of *Robert S. Duncanson*. Duncanson was listed as a "daguerreotype artist" in the Cincinnati city directories of the early 1850s. Ball displayed Duncanson's landscapes in his elegant successful photographic studio.[9]

Ball wrote this poignant pamphlet with integrity and sensitivity, similar to the style of the slave narratives that were published as authentic accounts of a slave's experience. Other narratives on slavery published that same year were Frederick Douglass' *My Bondage and My Freedom* and

Samuel Ringgold Ward's *Autobiography of A Fugitive Negro: His Anti-Slavery Labours in the United States, Canada & England*. Ball also exhibited his panorama in Boston's Armory Hall in the spring of 1855. During a short stay in Boston, Charlotte Forten, a free woman of color, later to become a well-known educator, wrote in her journal, "Ellen and I went to Boston. Went into the anti-slavery convention for a short time; was not able to stay long; in the afternoon went to see the Panorama, which I liked very much"[10]

PARIS AND LONDON

The earliest example of Ball's exhibitions occurred in 1855 at a state fair. *The Provincial Freeman* (formerly *Herald of Freeman*) noted on June 23 of that year, "Ball exhibits his Daguerreotypes at the Ohio Mechanics Annual Exhibition." As with most photographers of that period, Ball probably used this opportunity to promote his gallery.

In 1856, Ball traveled to Paris and London, where he is said to have photographed Queen Victoria.[11] *The Cincinnati Daily Enquirer* announced his imminent return in its newspaper on October 2: "Notice that Mr. Ball is returning from Europe within a few days."

While there is no documentation of Ball's personal life, it is likely that J. P. Ball married sometime in 1849 or 1850. He had at least two children from that marriage. One son, James P. Ball, Jr., was born on October 9, 1851, and a daughter, Estella Ball, of unknown birth date.[12]

Ball's business prospered in the late 1850s with the growth of the city of Cincinnati and its residents' fascination with the daguerreotype process. As a result of the success of his business, Ball soon opened another gallery. He hired his brother-in-law, Alexander Thomas, as a reception clerk. It appears that Alexander Thomas had recently moved to the city (1852) from New Orleans. He married J. P. Ball's sister, Elizabeth. In 1854, Thomas became extremely popular with Ball's clients and later became a partner, opening another gallery under the name of Ball & Thomas. Ball had short-lived partnerships with other galleries in the

city, one with Robert Harlan, another early daguerrean practitioner.

As Ball and Thomas' patronage increased, their clients became accustomed to reading advertisements in the local and regional newspapers promoting their unique services. The Ball & Thomas Photographic Art Gallery was destroyed by a tornado in May of 1860. The roof of the building which housed their studios "was carried away; part passed over the gallery of Ball & Thomas, while part went through the operating room, and some fragments of timber, etc., penetrated a salon in the rear of the photographic gallery, and killed a child and a woman. The gallery was a complete wreck, the instruments, chemicals, scenery, cases, pictures, carpets, furniture, and everything else were ruined. This was in the early days of the firm. All their available capital had been converted into stock, used in fitting up the gallery. Ball and Thomas were young men and they were colored men. They were facing financial ruin. Apparently, their business was at an end, but they were artists; and many white families in Cincinnati recognized them as such. Their white friends came to the rescue. The gallery was fitted up again most elaborately, and within a short time was known as "the finest photographic gallery west of the Alleghany Mountains."[13]

The public sentiment and support displayed by the community brought unprecedented success to Ball & Thomas. They hired additional operators and had more business than they could manage. They averaged an income of over $100 a day. With the success of the gallery, Ball and Thomas became quite affluent, maintaining a partnership for the next 20 years. It became a family enterprise. Thomas Carroll Ball worked as an operator until his death and Ball Thomas, son of Alexander Thomas, worked as a retouch artist. Ball boasted of his superior daguerreotypes, ambrotypes, and cartes-de-viste in local newspapers. His reputation drew several renowned sitters to his studio, including Henry H. Garnet, minister, editor and orator; Frederick Douglass; actress Jenny Lind; the mother of Ulysses S. Grant and many Union officers and enlisted men.

Despite his many successes in the city of Cincinnati, Ball dissolved his

partnership with Alexander Thomas, for reasons unknown, and moved to Minneapolis sometime in the late 1870s or early 1880s. There were many successful commercial photography studios in Minneapolis and St. Paul in the last quarter of the 19th century. The People's Photo Gallery was owned by one of the earliest black photographers in the city, R. Harry Shepherd, who opened his studio in the fall of 1887. Ball was well received by the citizens of Minneapolis. He advertised his tintypes and cabinet cards photographs regularly in the *St. Paul Western Appeal*:

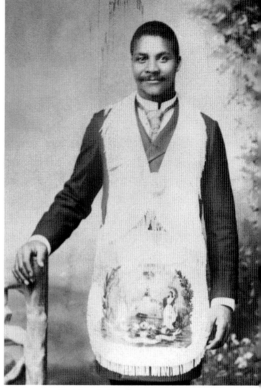

Unidentified Man
J. P. Ball & Son
(Courtesy Montana Historical Society)

"All…are just raving over Ball's artistic pictures. Ball is one of the oldest and best photographers in the Northwest and is the only colored man in the business."[14]

While the status of his first marriage remained unclear, in July of 1887, J. P. Ball married Annie E. Ewing, a schoolteacher from Mobile, Alabama, who had recently moved to the area "for the purpose of giving herself away."[15] Attending the wedding were a number of friends and relatives, including J. P. Ball's children, James P. Ball, Jr. and Estella Ball.

HELENA, MONTANA

In September of that year, J. P. Ball was commissioned as the official photographer for a celebration in honor of the 25th anniversary of the Emancipation Proclamation. Among the principal speakers was the Hon.

207

John Mercer Langston (who became a congressman for the state of Virginia, 1890-91). A month later, notices of Ball's "removal" to Helena, Montana, began to appear frequently in the *Appeal*. Civil rights organizations sprang up throughout the country and meetings were convened to discuss the plight of African Americans. A civil rights convention was planned for December 5, 1887 and J. P. Ball was nominated as a delegate from the area. A short notice of his departure to Helena was published in the *St. Paul Western Appeal* on December 24, 1887: "Prof. J. P. Ball spent several days in St. Paul prior to leaving for Helena, Mon., where he and his son have a photograph gallery. The Prof. tenders his thanks to the people of our city for their liberal patronage."

The Colored Citizen, a weekly newspaper published and edited by his son, James. P. Ball, Jr., was short-lived. It published articles about African Americans in the Northwest, and specifically, highly charged editorials about the plight of blacks who lived in the city of Helena. A lengthy notice announcing J. P. Ball's early years in Helena appeared in the paper on September 3, 1894:

> *Helena enjoys the notoriety of having the only colored photographer in the Northwest. Mr. J. P. Ball, who has had a studio here for a number of years, has a large patronage among many of our best citizens. He is one of the oldest members now in the profession, dating back to 1845, the famous daguerreotype era, and has had the satisfaction of taking numerous medals for superior work over many of the most skillful and artistic competitors in the largest eastern cities. Prior to, during, and for several years after the war, Mr. Ball had one of the largest and best equipped studios in Cincinnati.*

Ball, who was not to achieve success as a politician himself, ran for offices with the Republican party while living in Montana. He was elected as one of the "colored" delegates to attend the Republican party convention in 1894. He became president of the Afro-American Club, a social and political organization in the state. He was also nominated for the

office of coroner for the county of Lewis and Clarke, Montana, but declined, stating that were he to accept, "My business interests are such that they would be greatly jeopardized."

During this period, Ball was indeed busy in the city of Helena, judging by the number of his photographs of the white and black community, as well as the documentation of the constructing and building of the state capitol in the city of Helena. Additionally, he photographed attendees at local conventions, recent immigrants to the area, the public execution of John Biggerstaff, and William Gay, a white man, by the sheriff and townspeople.

GLOBE PHOTO STUDIO

It is likely that Ball moved to Seattle in 1900, as was suggested by frequent newspaper accounts in the *Seattle Republican* (a weekly black newspaper) about the activities of James P. Ball, Jr. and Sr. By that time, James P. Ball, Jr. had become a lawyer and had a practice for a number of years while maintaining his interest in photography. James P. Ball, Sr., then 75 years old, opened another photographic studio under the name of Globe Photo Studio. It appears that the entire Ball household, sons and daughter, worked for a while at the studio.

Although there are differing accounts of James P. Ball's later years, it is probable that he married a third time, and his wife may have assisted him in his new studio. He founded and organized Shriners' lodges in Seattle and Portland and sold advertisements for the *Seattle Republican*.

The Globe Photo Studio maintained an active business through 1904. During this time, Ball suffered from crippling rheumatism and sought relief in a more appropriate climate outside of Washington. Little is known about the circumstances surrounding his death. It is thought that J. P. Ball's long and productive career ended in 1904 in Hawaii. While greatly celebrated in his lifetime, it is through the photographic collections, newspaper clippings, and citations from books that we capture the legacy of this phenomenal man, James Presley Ball.

Gordon Parks and the Image
of the Capital City

For me the function of a photographer; I think it's just to report accurately
the way we live...our social system, our moods, what we think is ugly, what
beautiful. The photographer's job isn't to change these things; he just shows
them up as they are, and the people take it from there.

—Gordon Parks

Gordon Parks, who called himself "a reporter with a camera," has
been noted for his direct, realistic style in photographing life in America,
particularly during his short tenure as a Farm Security Administration
(FSA) photographer. Born in Fort Scott, Kansas, on November 30, 1912,
Parks was the youngest of 15 children. He lived an extraordinary life
before 1950. As a teenager, he worked as a cowpuncher and played cornet
in the school orchestra; and he was at various times a waiter, a porter, a
piano player in nightclubs, before he became a photographer.

After his mother's death when he was 16, Parks left Kansas for
Minneapolis to live with an older, married sister. He found a job as a
waiter on the Northern Pacific Railroad, which traveled from
Minneapolis-St. Paul to Seattle via Chicago. Riding the rails was lucra-
tive and inspiring. He wrote musical compositions and read voraciously.
"On quieter runs," he says, "in between meals, when the wealthy passen-
gers were either sleeping or consuming alcohol in the lounge cars, I read
every magazine I could get my hands on."

Many of these magazines had images by photographers hired by the
FSA (one of President Franklin Delano Roosevelt's New Deal programs)
who traveled the country photographing rural and urban America from
1935 to 1943. The photographers he studied in these magazines were
Ben Shahn, Jack Delano, Carl Mydans, Dorothea Lange, John Vachon,
and Walker Evans. "They were photographing poverty, and I knew
poverty so well," Parks recalls. "They were covering Okies in California.

It was the Steinbeck era." Parks' admiration of the courage and of the work produced by these photographers, convinced him that he, too, should become a photographer.

One particular discovery changed Parks' life forever. He recalls:

In one {magazine}that had been left behind by a passenger I found a portfolio of photographs that I would never forget. They were of migrant workers. Dispossessed, beaten by storms, dust and floods, they roamed the highways in caravans of battered jalopies and wagons between Oklahoma and California, scrounging for work. Some were so poor that they traveled on foot, pushing their young in baby buggies and carts. They lived in shanties with siding and roofs of cardboard boxes, the inside walls dressed with newspapers. There was a man with two children running through a dust storm to their shanty....These stark, tragic images of human beings caught up in the confusion of poverty saddened me. I took the magazine home and studied it for weeks. Meanwhile I read John Steinbeck's Dubious Battle *and Erskine Caldwell and Margaret Bourke-White's* You Have Seen Their Faces. *These books stayed in my mind.*[1]

Within weeks of studying the images in that periodical he found on the train, Parks bought his first camera, a Voightlander Brilliant, at a pawnshop for $7.50. He states that this first purchase was "not much of a camera, but a great name to toss around. I had bought what was to become my weapon against poverty and racism."[2]

Parks, by then married with a child, began to dream and to critically assess his future as a porter on the train. Despite his extended trips away from his family, the long layovers in Chicago, and the nature of his job, the job still fulfilled his diligent quest to understand and explore his creative urges. His passion led him to visit the Art Institute of Chicago, "spending hours in this large voiceless place, studying paintings of Monet, Renoir and Manet."[3] He also visited the Southside Community Art Center, dubbed the unofficial auxiliary of the art institute. There he

211

met Charles White, the noted black artist who lived in Chicago during this period. White described his own work as taking shape around images and ideas centered on the life experience of a Negro: "I look for security in alliance with the millions of artists throughout the world with whom I share common goals. And I look to all mankind to communicate with and to appropriate my works."[4]

Parks' experiences during his layovers in Chicago, particularly his interaction with White and other artists at the Southside Community Art Center, brought a new consciousness to his own passion to create art. Parks expresses the impact of White's work on his photographic vision:

There were a number of talented young people who worked at the Center during those days, and one of the most promising was Charles White, a painter. He was mild-appearing, bespectacled, and blessed with humor, but his powerful, black figures pointed at the kind of photography that I knew I should be doing....It was good to laugh and talk with him; and it was good to watch him strengthen an arm with a delicate brush stroke or give anguish to a face with mixtures of coloring. We had great hopes.[5]

Parks recalls the details of this period with great nostalgia:

The first few rolls I had taken with {my new camera} were earning respect from the Eastman Kodak Company. The manager of its Minneapolis branch showed surprise when he found out they were my very first attempt, and he emphatically assured me that they were very good. He promised me a showing in their window gallery if I kept progressing. Dubious, I thanked him, smiled and told him I would hold him to his promise. After that, hardly a thing faced my Voightlander that I didn't attempt to glorify—sunsets, beaches, boats, skies, even an elaborate pattern of pigeon droppings on the courthouse steps. I wasn't rushing to the bank with proceeds from those first efforts but experience was mounting, giving me a sense of direction. The gentleman at Eastman lived up to his promise; six months later he had my photographs placed in the company's show windows.[6]

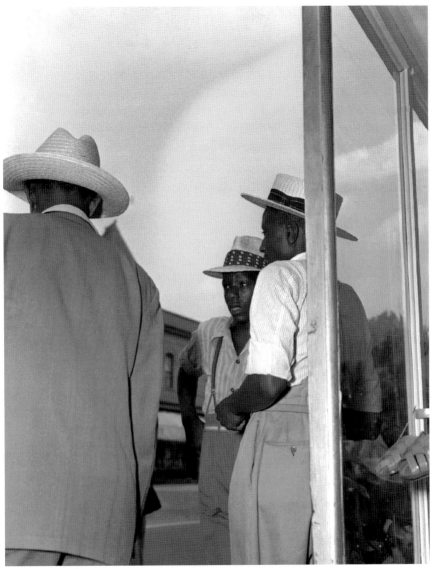

Saturday Afternoon on 7th Street and Florinday Avenue, NW, Washington, DC, 1942
Gordon Parks
(Courtesy Library of Congress)

He later found the images he made of the waterfront insignificant and turned his camera on a new subject. "Natural instinct had served to aim my sights much higher, and those Farm Security photographs with all their power were still pushing my thoughts around." He goes on to say:

Before long, I had deserted the waterfronts, skyscrapers and canals for Chicago's south side—the city's sprawling impoverished black belt. And there among the squalid, rickety tenements that housed the poor, a new way of see-ing and feeling opened up to me. A photograph I made of an ill-dressed black child wandering in a trash-littered alley and another of two aged men warming themselves at a bonfire during a heavy snowfall pleased me more than any I had made. They convinced me that even the cheap camera I had bought was capable of making a serious comment on the human condition. Subconsciously, I was moving toward the documentary field, and Chicago's south side was a remarkably pitiful place to start. The worst of it was like bruises on the face of humanity.[7]

Captivated by documentary photography, Parks found it necessary to spend more time in Chicago. "I increased my visits to Chicago and to its Southside Art Center which sat formidably in the heart of the black belt," he recalls.

Once a stately mansion owned by the rich, it was now a haven for struggling black artists, sculptors and writers. The gallery walls were usually weighted with the work of well-known painters who used their art to encourage protest from the underprivileged and dispossessed. How effective they were remains questionable, but for Parks, at the time, their approach to art seemed commensurate with the people they were attempting to serve.[8]

Parks had become enraptured with photography. The artist was maturing; he could see the photograph not only as poetic rendering but also as lyrical musing. He looked for inspiration from art that evoked compassion for the subjects portrayed. "On exhibit inside," he recalls,

214

"were the works of Raphael Soyer, Charles White, Ben Shahn, Max Weber and Alexander Brook, along with the merciless satires of William Gropper and Jack Levine." He continues:

Oppression was their subject matter. With paint, pencil and charcoal, they had put down on canvas what they had seen, and what they had felt about it. Quite forcefully, they were showing me that art could be most effective in expressing discontent, while suggesting that the camera—in the right hands—could do the same. They had forsaken the lovely pink ladies of Manet and Renoir, the soft bluish-green landscapes of Monet that hung several miles north at Chicago's Art Institute. To me, these classicists were painters who told far different tales, and for several weeks, the difference between the two schools—one classical, the other harshly documentary—would expand the possibilities of the artistic directions I could take.[9]

An award from the Julius Rosenwald Fund in 1941 provided Parks with a renewed enthusiasm for his art. One weekday afternoon, when Parks was visiting the center, Charles White told him about the fund. Despondent because he had not yet received a fellowship, White suggested that they both apply for one. Parks enthusiastically agreed. He decided to photograph life on the south side of Chicago and use that work to apply for the fellowship. Using his poetic approach of documenting and interpreting poverty, he began the project that would ultimately transform his life.

That Saturday morning, I started poking around the south side with my camera. I knew that more than anything else I wanted to strike at the evil of poverty....My own brush with it was motive enough, yet this landscape of ash piles, garbage heaps, tired tenements and littered streets was worse than any I had seen.[10]

215

Parks photographed the perpetual reality of poverty. He recorded funerals, church services, families, gamblers, police brutality, and the desperate lives of the children who lived in the area. He wrote to art historian and philosopher Alain Locke, writer Horace Cayton, and the Center's director, Peter Pollack, requesting letters of support for the Julius Rosenwald Fellowship. Pollack and his staff organized an exhibition of the photographs Parks had made, including his landscapes and the south side images.

Reflectively, Parks writes:

During that first year there {in Chicago} my family learned to spell 'suffer.' But just when food and money hit the zero mark, fate resurrected my hopes.... Writers, painters, sculptors and scholars had been recipients of fellowships but never a photographer.[11]

Initially rejected by the first group of jurors, who were all white, well-established photographers, Parks' photographs received a reprieve when they were reviewed by another jury composed of painters and sculptors. In December of 1941, Parks received notice that he was the first photographer to receive a Rosenwald fellowship and the $200 a month that went with it. That same month, Pearl Harbor was attacked and World War II began. It was also around that time that Richard Wright wrote *Twelve Million Black Voices*, using FSA photographs to examine the plight of black life. Its style and premise were similar to Caldwell and Bourke-White's *You Have Seen Their Faces*.

Parks joined the FSA in January 1942.

I was to serve out my fellowship with the Farm Security Administration with those same photographers whose work had beckoned to me when I was a waiter on the North Coast Limited. It was an extravagant moment as we began packing, and for the next two years, Washington, D.C. would be our home.[12]

Parks chose to work with Roy Stryker at the Farm Security Administration. He received extensive training as a photojournalist under Stryker's direction. He describes with candor and respect the advice he received from his mentor.

> *I learned a lot from Stryker. He wasn't a photographer himself but he knew which way the camera should be pointed. He made me look at the camera as a very purposeful instrument…it became the weapon to speak against anything we disliked in the world of fact.*[13]

Parks expresses his initial feelings of exuberance and apprehension toward Washington, D.C.:

> *I arrived there in January of that year with scant knowledge of the place.… Sensing this, Roy Stryker, sent me out to get acquainted with the rituals of the nation's capital. I went in a hurry and with enthusiasm…My contentment was short-lived. Within the hour, the day began opening up like a bad dream; even here in this radiant, high-hearted place racism was busy with its dirty work. Eating houses shooed me to the back door; theatres refused me a seat.*

His past memories of racism, poverty, and deprivation came back in a single afternoon. The insults he received at Garfinckel's department store and the insensitivity of the whites he encountered in the city embittered him. Parks regarded all racial insults as personal affronts.

> *It suddenly seemed that all of America was finding grim pleasure in expressing its intolerance to me personally. Washington had turned ugly, and my angry past came back to speak with me as I walked along, assuring me that, even here in the nation's capital, the walls of bigotry and discrimination stood high and formidable.*

Returning to the FSA offices, Parks met with Stryker, who informed him that he was concerned about the photographer being able to cope with the racism of the nation's capital. Stryker declared, "As for that city out there, well, it's been here for a long time, full of bigotry and hatred for black people. You brought a camera to town with you. If you use it intelligently, you might help turn things around. It's a powerful instrument in the right hands." Stryker went on to say:

Obviously you ran into some bigots out there this afternoon. Well, it's not enough to photograph one of them and label his photograph 'bigot.' Bigots have a way of looking like everyone else. You have to get at the source of their bigotry. And that's not easy. That's what you'll have to work at, and that's why I took you on. Read. Read a lot. Talk to other black people who have spent their lives here. They might help to give you some direction.

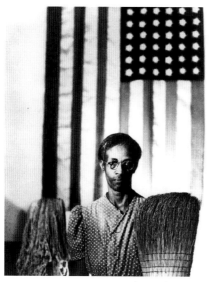

American Gothic, 1942
Gordon Parks
(Courtesy of Photographer)

Having spent only a few days in Washington, and with a curious combination of training in photography and literary inspiration, Parks took a photograph that is now known as his signature image, one of the first he took in the capital: *American Gothic*. It is of an African American cleaning woman in a government office building. Roy Stryker had suggested that the photographer speak with her and find out her views on life. Parks spent a great deal of time with her, photographing her at work and at home, and developed a

masterful photographic essay about Ella Watson, the cleaning woman. He later commented:

> *What the camera had to do was expose the evils of racism, the evils of poverty, the discrimination and the bigotry, by showing the people who suffered most under it...The photograph of the black cleaning woman standing in front of the American flag with a broom and a mop expressed more than any other photograph I have taken. It was the first one I took in Washington, D.C. I thought then, and Roy Stryker eventually proved it to me, that you could not photograph a person who turns you away from the motion picture ticket window, or someone who refuses to feed you, or someone who refuses to wait on you in a store. You could not photograph him and say 'This is a bigot.'*

It is the facial expressions in Parks' photographs that tell the story—of hard work and hardship, of the struggle of people's daily lives—whether the subject is a cleaning woman or an old street vendor, a construction worker or a panhandler, or children in the doorway of their home. He captures them in what is seemingly an unguarded moment. *American Gothic* is reminiscent of Langston Hughes' concept of "the dream deferred." Parks' image is about second-class citizenship, the disinherited.

Parks' documentation of the peculiar quality of life of blacks living in the nation's capital, reveals a strikingly different manner from that of the African American studio and journalistic photographers who thrived in Washington, D.C., during the 1930s and 1940s. The studio and newspaper photographers documented the world of the upper and middle classes: weddings, cotillions, annual dinners. Parks looked at the social implications of the underemployed and their children; he made thought-provoking images of the disenfranchised. Stylistically, he became adept at fusing the artistic with the journalistic. As historian Nicholas Natanson so aptly states, "Parks does not stint on irony."

The racial and social implications of Parks' photography are apparent in his images of the family of Ella Watson. In one of Parks' more subtle

photographs, in which a young black girl holds a white doll, he begins to suggest the identity struggle that points to the African American self-image and how much it has been defined by the values and standards of the larger culture. Parks' photographs of the young girl and her grandmother, who might have purchased the doll, challenge the idea of material fulfillment which results in the loss of self.

Parks, like the other documentary photographers of the FSA, created politicized images of the social conditions of the underemployed. Simply put, his photographs define African Americans in relationship to the "owning" class, the have-nots and the haves. His suggestive imagery of the black community as a colonial outpost in the shadow of the Capitol dome mirrors the writings of Richard Wright in *Twelve Million Black Voices*. Wright states:

The seasons of the plantation no longer dictate the lives of many of us; hundreds of thousands of us are moving into the sphere of conscious history....We are with the new tide. We stand at the crossroads. We watch each new procession. The hot wires carry urgent appeals. Print compels us. Voices are speaking. Men are moving! And we shall be with them.

Parks recorded the dramatic duality of life in Washington, D.C. The key to understanding Parks' images lies in a description of the social history of the capital at this time. While the population of all but eight or nine American cities declined during the decade, Washington's increased by 36 percent. Before midsummer of 1940, the number of federal employees in the city had risen to about 166,000. Black businessmen had little stake in this mounting prosperity. Although the nearly 42 percent increase in the Negro population outstripped the 34 percent white increase, Negro purchasing power rose relatively little, if at all, during the decade. The building trades unions, the bulwark of organized labor in Washington, kept African Americans out of skilled construction jobs, and hopes that the Capital Transit Company would hire Negro platform

workers collapsed when the Transit Union threatened a walkout if a single Negro were employed. Year after year, moreover, an unrecorded number of practically destitute Negro families arrived from the Southern states to swell the District's unskilled labor supply.

This description of Washington is important, as it distinguishes the subjects Parks photographed. Equipped with a sensitivity toward poverty, Parks provided poor families and the unemployed with visual empowerment. In one of his photos, the interior of Ella Watson's home reflects her sense of family and religion. A framed photographic portrait of a well-dressed couple is placed prominently on her dresser. The photograph, possibly of Mrs. Watson with her husband prior to her husband's death, is somewhat anecdotal. The composition shows the scarcity of treasured possessions in Mrs. Watson's life; all she has are the photograph and her grandchildren. The reflection of Mrs. Watson's adopted daughter is seen in the mirror's surface. As accomplished as this photograph is in telling her family story, another of Parks' photographs also dramatically represents how important religion was to Ella Watson. In this photograph, there is an "altar" with religious icons on another dresser. Mrs. Watson and her adopted daughter look as though they are in deep thought as the viewer's gaze is transfixed on the symbolic statuary figures, which include a crucifix, rosary, and two elephants. The mystical fusion of the religious and the allegorical good luck figures creates a wonderful paradox.

To contrast the images of Mrs. Watson's home, Parks walked throughout the streets Washington. His images demonstrate that he was not static. Two undeniably distinctive Parks photographs of the contrasting housing situation in Washington create a curious tension. In one image, two young boys stand on a hilltop overlooking the newly-built housing project, Frederick Douglass Dwellings. The photograph creates a sense of hope and a possibility of dreams fulfilled by these new houses. The housing project on Alabama Avenue included 313 four-and six-room units. The image of it includes two young boys in the fore-

221

ground shooting marbles. The photographer captures the young boys at play, oblivious to the awkward structures in the background—the facades of their homes. Questions naturally arise about the romanticized nature of both photographs: the photographer has combined the real with the surreal.

Commenting on Parks' approach to photographing his subjects, photographer Robert H. McNeill states:

> *I remember seeing him covering a Howard University commencement, and even the other black photographers who were there were saying, 'Who is that crazy {guy}?' I mean, Gordon would use four flashbulbs for a single shot, outdoors where he could have gotten away without using any. He wasn't content just to stand up and take shots from a position that was comfortable for him—he lay on the ground, he shot up, he shot down. He was more like a movie director, trying to capture the whole academic atmosphere.[14]*

During World War II, Parks worked for the Office of War Information (OWI) as a correspondent. He was assigned to document life in wartime Washington and photograph the black airmen stationed in Sheffield, Michigan. He later became a photojournalist with the Standard Oil Company in New Jersey, again under the direction of Roy Stryker, photographing the "face" of America, its problems and its people. In 1949, Parks became a staff photographer for *Life* magazine and was active covering stories of interest to black and white America.

The importance of Gordon Parks' work to the genre of documentary photography is beyond question. It is Parks' own documentation and analysis of the historical struggles of black people that authenticate his photographs. The challenge he presented to Roy Stryker and his colleagues resulted in a broader reading into the works produced by the FSA and photographers, as Parks transformed his subjects and their plight.

Charles "Teenie" Harris: Portraits of the Hill

Black photographers pioneered in the development of the daguerreotype, contributed to the "pictorial aesthetic" dominant during the early 20th century, breathed new life into urban realism....

—Robin D. G. Kelley

During Charles "Teenie" Harris' long life (1908-1998), he created a visual social history of the African American experience and made major contributions to documentary photography. "I've had a camera since I was three years old," said Harris. "It makes me feel good because everybody now says, 'You took such good pictures.' Well, I guess I had an eye for it." Harris had more than just an "eye for it." With his photographs, he did exactly what Kelley said black photographers were doing at the time, he "breathed new life into urban realism."

Born in Pittsburgh, Pennsylvania, Harris was a prominent member of the city's Hill District, the vibrant black community. He received his nickname, Teenie, because "a lady from Detroit, Miss Alexander, she called me Teenie Little Lover when I was a little boy, and then when I got big, they took the 'Little Lover' part off."

A self-taught photographer, Harris received guidance from *Pittsburgh Courier* photographer Johnny Taylor. His first professional association with the medium occurred around 1931, when he acquired, with the assistance of his brother, his first Speed Graphic, a 4x5 hand-held camera used by most newspaper photographers at that time. During his career, Harris used a variety of cameras, including a Rolleicord, a Crown Graphic, and several 35mm cameras.

Although Harris was based in Pittsburgh, he made a series of photographs for *Flash!*, a black-owned, D.C.-based weekly news picture magazine. His initial involvement with the magazine was as a salesman, but he soon found it more profitable to take photographs of the celebrities who frequented the Pittsburgh community and sell the images to *Flash!*

Before he became a photographer, Harris was a baseball player with the Pittsburgh Crawfords, one of the two Negro Baseball League teams in Pittsburgh at the time. His photographs of team members like Josh Gibson and Jackie Robinson, jazz musicians and vocalists like Duke Ellington, Count Basie, Ray Charles, Billy Eckstine and Lena Horne; and other well-known Pittsburgh people tell a story about the thriving life of blacks in American cities.

Harris was especially adept at capturing candid poses while documenting social and sporting events in the area. Soon, Harris' work came to the attention of Frank Bolden, an editor for the *Pittsburgh Courier*, a national black news weekly. Harris freelanced with the newspaper for a number of years before he was hired in 1936 as the paper's chief photojournalist. Bolden, then the city editor, described Harris as a visual story teller, one whose "pictures all told a story."

When Harris entered the photography profession, Pittsburgh's black community was growing rapidly as blacks migrated to the area looking for employment. The decrease in European immigration during World War I forced employers in Pittsburgh to seek out black workers to fill their depleted labor force. The iron and glass industries hired large numbers of African Americans for the first time.

As a result, the cultural life of black Pittsburgh flourished in the interwar years. The center of the black community's nightlife was located on Wylie Avenue, where Harris created an extensive documentation of black life from the post-Depression period through the post-civil rights era.

Harris described his approach to photography:

They called me 'One Shot' cause that's all I ever took. Mayor David L. Lawrence named me that. Whenever I'd go into him, there'd be four, five, six photographers there and they'd be shootin', shootin' shootin'. I'd wait for them to get through. Then I'd walk up and—bam! One shot. And he liked that.[1]

For more than 50 years, Harris photographed black social events, church groups, organizations, restaurants, and nightclubs for the *Courier*. Then he opened Harris Studio on Centre Avenue in the Hill District, eventually moving the business to the basement in his home. "Harris was the first person to see black people with dignity, more than anyone else did. He portrayed black people in a warm and caring light," said Greg Lanier, a black freelance photographer. "There's a reason that he had all the access that he did. People trusted him, and they knew they would be portrayed in a good light and not exploited."

Harris documented the realities of a segregated Pittsburgh at mid-century, and his images covered a wide range of subjects, from proud families, to protest marches against discriminatory employment practices, to the social life of the black fraternities and Masonic organizations.

Harris' photographs reveal a complex history of African American life, one that boasted community wealth and pride. His pictures of social events, coupled with interior shots of black-owned businesses with happy and satisfied clients, political leaders at rallies and demonstrations, allow the viewer to appreciate the importance of this photographer's vision of his community. They also illustrate the economic and political successes of these struggling and working class residents and documented the realities of urban life.

The realistic nature of his images serves as a visual narrative to the portraits. They illuminate the life of a community and illustrate everyday encounters in a profound and expressive manner. Harris was the first African American photographer to join the Pittsburgh Chapter of the Newspaper Guild. He recorded the African American social landscape in a high photojournalist manner.

Harris' images, whether street scenes or sports gatherings, are consciously made portrait studies of the Hill and its people. He often moved in close to his subjects—sometimes capturing a full room of people sharing a single moment—seeming to invite the viewer to become immersed in the scene. His camera captured brief visual moments that linger and

remind us of the power of his vision and photographic skills.

Harris' photographs were made during a complex period within African American historical memory, the New Negro and the Depression era years of the 1930s. During this period, the idea of the New Negro became an important symbol of a new race consciousness between 1900 and 1940. African American photographers like Harris often made imagery of their subjects not seen in the wider community. Art historian Camara Holloway writes:

The New Negro {imagery} destroyed the illusions required to justify segregation. Although the creation of the New Negro iconography did not immediately yield the desired transformation of American society, the activity around this symbol was an important step in the black struggle for civil rights. Blacks needed a means to affirm themselves, and the portrait as symbol provided a critical psychical armature upon which to build a valorized identity.[2]

Through the Harris Studio doors came entrepreneurs as well as members of the working class; laborers, coal miners, steel workers, cooks, domestics, journalists, musicians, and educators. Harris supported his family with the income from the portraits he made of these people as well as from weddings and baby pictures. His photographs were affordable and their low cost made him popular.

At the same time, photography was moving more directly into the national psyche. With the black newspapers and journals publishing images by black photographers, they began to emerge as the visual urban "griot," or storyteller, actively photographing the economic, artistic and political successes of their communities. Harris' images reflected people who were proud of their race and their community.

Harris' photographs reveal that black people were concerned about how they were portrayed. These images of pride in appearance were transferred to other blacks—a communal image of prestige and power. Photography is a powerful tool—both for those in front of the camera

and those behind the camera.

It is apparent from an examination of Harris' photographic archives that most of his African American clients wanted to celebrate their achievements and establish an image that bespoke a sense of self and self-worth. Images by photographers like Harris functioned as visual testimony for their subjects, reflecting the explosion of creative endeavors that gave national prominence to everyday people as well as the artists, educators, historians, and philosophers who were captured by their lens.

Curator Linda Benedict Jones writes of Harris:

His photographs nourish us precisely because they provide a point of view that is familiar, intimate, and caring. As a member of the community where he worked, he portrayed what he knew and we are the beneficiaries of the moments he captured.[3]

Teenie Harris had a great skill for portraying dignity, whether he was documenting women working in a bakery, black soldiers during World War II, or men playing a serious game of checkers. He liked the people he photographed. His photographs of race leaders, politicians, celebrities, and the community portraits reveal his sensitivity and his desire to capture intimate moments that tell a story.

Memory

Exposure: Civil Rights Photography

> I find it difficult to look at these photographs without flinching from the memories and from the anger they invoke. But I must look. I must remember, as you must. For this was history in the making. Like it or not, you cannot hide from the camera's eye.[1]

—Myrlie Evers-Williams

Life in America between 1942 and 1968 was a time of racial strife and new social awareness. Photography played a crucial role in documenting and re-interpreting the varied experiences of living in a segregated society. From its beginnings, photography was used to define, oppress, and subjugate, but it also was used in positive ways. A close examination of private family photographs indicate that photography was also used to document and celebrate. During the first decades of the 20th century, photography as an art form and as a vehicle of popular culture, moved more directly into the national psyche. Documenting family activities as well as the faces of young children was important to many American photographers. Baby and beauty contests were among the types of images offering a new paradigm in which to express black culture.[2]

Contending that "all art is propaganda," W. E. B. DuBois, the editor of *The Crisis* magazine, used the photograph to promote positive aspects of the black race. With the introduction in 1910 of photographs, *The Crisis*, the journal of the National Association for the Advancement of Colored People (NAACP), doubled in size. As evidenced in Daylanne English's essay, *DuBois's Family Crisis*, DuBois created a visual taxonomy in which to read photographs of black people. English argues that:

> *Under DuBois' editorship,* The Crisis *comprises a kind of eugenic 'family album,' a visual and literary blueprint for the ideal, modern black individual...{His} column functions to counter racist representations of African Americans by the white press; but given the predominantly black readership of the* Crisis, *such compulsive cataloging also serves to keep the 'family' updated on its members' activities.*[3]

Immediately following World War II, a large number of black Americans found work as preachers, tenant farmers, factory and domestic workers, teachers, and cooks throughout the rural South. Many moved to urban centers like Detroit, Chicago, Oakland, New York, and Los Angeles hoping for a new life outside of poverty and discrimination. The photographs of this era create a new historical consciousness that has the power to rewrite history itself. Central to this new visualization were images that depicted life within the margins, images of beauty, advertising, and work, representing a vibrant community of men, women, and their sons and daughters who fought to achieve their rights. No doubt this informed consciousness created an undeniable and collective power. Family and community life were important, and protecting the family was paramount. This changing attitude was captured most evocatively through the photographic medium.

Throughout his early years as editor of *The Crisis*, DuBois published hundreds of photographs of "Prize Babies." As historians Shane White and Graham White observed, "there were babies on the cover, pages with sixteen photographs of babies, half-page shots of babies, babies in cute outfits, and even naked babies artistically arrayed on rugs."[4] The photographs showed black children as the pride of the race as a whole. DuBois wrote:

These are selected children; but careful consideration of the total pictures received by The Crisis*…makes it seem certain that there is growing up in the United States a large and larger class of well-nourished, healthy, beautiful children among the colored people.*[5]

With the post-war migration, more and more black men and women also experienced racial discrimination, physical and emotional abuses, economic rejection, and too often, death. I will never forget the photograph of the brutally beaten and swollen body of the young Emmett Till published in *Jet* magazine in 1955. Photography played a significant role in Till's life that summer of 1955, prior to his murder and after.

He had brought with him photos from his junior high school graduation in Chicago, which showed both black and white students. Seeing that the Southern children were impressed, Emmett commented that one of the white girls in the photographs was his girl friend. This prompted one of the local boys to say, 'Hey, there's a white girl in that store there. I bet you won't go in there and talk to her.' Calling the boy's bluff, Emmett went in, bought some candy, and as he was leaving the store, said to the woman, 'Bye, baby,' for which he was beaten to death.[6]

Memphis-born Ernest Withers (b. 1922) was hired as a photographer for the Emmett Till murder trial, which lasted a week. The all-white, all male jury found the white male defendants not guilty.[7] After the trial, Withers returned to Memphis where he co-published and distributed a pamphlet on the murder trial of young Emmett Till, entitled *Complete Photo Story of Till Murder Case*. It was sold for one dollar a copy. This act revealed Withers' concern for preserving the memory of this horrific experience. As he wrote in the circular:

> *...we are not only depicting the plight of an individual Negro, but rather of life as it affects all Negroes in the United States....In brief, we are presenting this photo story not in an attempt to stir up racial animosities or to question the verdict in the Till Murder Case, but in the hope that this booklet might serve to help our nation decide itself to seeing that such incidents need not occur again.[8]*

Many families experienced episodes of hostile confrontation that intensified during the years of the social protest movements. Blacks were being killed, hosed, jailed, and subjected to Jim Crow laws throughout the American landscape. Photographers witnessing both brutal and social assaults created a new visual consciousness for the American public, establishing a visual language of "testifying" about their individual and collective experience.

As photographer Danny Lyon recounts about his experience in Albany, Georgia:

Smoking a corncob pipe, drifting in and out of the southern accent he had picked up in Mississippi, SSNC {Student Non-Violence Coordinating Committee} executive secretary James Forman was serious, extremely polite, and always under pressure. Forman treated me like he treated most newcomers. He put me to work. 'You got a camera? Go inside the courthouse. Down at the back they have a big water cooler for whites and next to it a little bowl for Negroes. Go in there and take a picture of that.' With Forman's blessing, I had a place in the civil rights movement that I would occupy for the next two years. James Forman would direct me, protect me, and at times fight for a place for me in the movement. He is directly responsible for my pictures existing at all.[9]

Lyon's photograph plainly depicts the horrific reality of black people in Albany. As the perfect visual metaphor for "Jim Crow", this photograph, like many others of its type, mobilized the protest movement. The segregated signs—one marked "colored" and the other "white"—simply demonstrate what it meant to be a member of the privileged class. The "white" water fountain was larger, free flowing with a quick switch of the dial; while the drinking water fountain for the black man, woman, or child, short or tall, was anything but equal—theirs was the size of a small bowl that appears to be not even three feet from the floor.

Jack Franklin (b. 1922) was another photographer active in the civil rights movement. He became a major figure in photojournalism in Philadelphia, covering protest marches and civic and political leaders in the Philadelphia area. During the early 1950s, Franklin worked as a staff and freelance photographer for periodicals such as *Sepia* and *Tribune*. He documented numerous social events for churches, club, and organizations. Franklin, like the other socially committed photographers who emerged during the 1960s, photographed the political milieu during the period of social unrest in the major cities of this country.

Commenting on this era Franklin states: "The civil rights movement was the highlight of my photography...the march on Washington, the march from Selma when Martin Luther King was alive..."

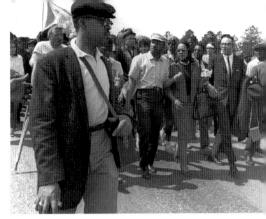

On June 19, 1963, seven days after the murder of NAACP leader Medgar Evers in Jackson, Mississippi, a civil rights bill was introduced in the U. S. Senate. The year 1963 was pivotal in the visualization of racial discontent: Charles Moore photographed the

Dr. & Mrs. King, Ralph Bunche and C. Delores Tucker enroute to Montgomery, 1965
Jack Franklin

Birmingham Riots, and hundreds of photographers witnessed the March on Washington. Photography was instrumental in galvanizing young people, motivating cultural change and defining the significance of the struggle for human and civil rights that eventually forced the federal government into creating laws against racial domination and discrimination. Photographs of anonymous Americans and leading figures such as Martin Luther King, Jr. and Malcolm X marching, protesting, participating in sit-ins, and attending rallies showed the world that blacks were indeed fighting back. The new Southern black was depicted as rebellious and defiant. Moore's photographs of Martin Luther King's arrest show graphic evidence of this new black citizen. Dr. King, wearing a hat and suit, is jostled by police officers. The underlying tension in the image can be found in King's own words:

> *The tension which we are witnessing in race relations in the South today is to be explained in part by the revolutionary change in the Negro's evaluation of himself...You cannot understand the bus protest in Montgomery without understanding that there is a New Negro in the South.*[10]

By the early 1960s, the protest movements had become a national crusade for human rights for all oppressed people. Newspapers and magazines throughout the world had published gripping images of racial hatred and police brutality in Birmingham, Selma, Montgomery, Oakland, and Los Angeles. The most brutalizing events caused photographers to speak out en masse.

On April 27, 1962, there was a shootout between the Los Angeles police and members of the Nation of Islam; Ronald Stokes, a member of the Nation of Islam, was killed. Fourteen Muslims were arrested; one was charged with assault with intent to kill and the others with assault and interference with police officers. A year later, Elijah Muhammad sent Malcolm X to investigate the incident and the trial. Gordon Parks' remembers his photograph of Malcolm X holding the brutally beaten NOI member in this way:

> *I remember the night Malcolm spoke after this brother Stokes was killed in Los Angeles, and he was holding up a huge photo showing the autopsy with a bullet hole at the back of the head. He was angry then, he was dead angry. It was a huge rally. But he was never out of control. The press tried to project his militancy as wild, unthoughtful, and out of control. But Malcolm was always controlled, always thinking what to do in political terms.[11]*

The civil rights movement was unfolding on the streets in virtually every rural and urban city in America. Reporters, photographers and students from television stations, newspapers, and magazines were on hand to document the conscience of this country. The small triumphs in local communities and the disappointments in the larger cities are forever etched into our memories because of the camera. During this dangerous yet invigorating time, photographers sought to create a collective visual memory that would empower communities while at the same time provide evidence of the struggles, defeats, goals, and victories.

Empowering the Powerful: Photography and the Presidency

A good photographer needs to work while experiencing the emotions and the effects of the events that they are photographing, but they need to channel those emotions and their reactions through their camera and express them visually.[1]

—Bob McNeely

I can only imagine that photographing the President of the United States is both an arduous and daunting assignment for any photographer. Working for President Clinton and then working for the Kerry/Edwards campaign, Sharon Farmer has played an extraordinary role in history. President Clinton described their relationship in this manner:

> *My first day on the job was her first day, and I've been honored to have her by my side, literally, ever since. I am lucky to have Sharon as a friend, and every bit as lucky to have her as my Director of White House Photography— the first woman and the first African American ever to hold that post. Sharon Farmer is making history even as she records it.[2]*

As the 2004 campaign photographer for the Democratic candidate for President, John Kerry, Farmer was also responsible for creating Kerry's official image as the candidate and possible future president.

PRESIDENTIAL PHOTOGRAPHY

The first president to use photography as a visual communicative tool was James K. Polk. In 1846, Polk signed into law the establishment of a national museum, the Smithsonian Institution. That act indicated Polk's understanding of preserving historical memory. The best-known photographer of the presidency in the 19th century was Matthew Brady, who photographed President Abraham Lincoln. When Abraham Lincoln won

the presidency in 1860, he acknowledged the role that Matthew Brady's portrait had played in his election. President Lyndon Johnson was the first president to hire an official White House photographer. Prior to that, photographers working in other federal agencies—the Army, Navy, Air Force, National Park Service, etc.—were often assigned to cover the activities of the President for the historical record.[3]

SHARON FARMER

Farmer studied music in college, but became interested in photography while working in a camera store. During a career that spans more than 25 years, Sharon Farmer has made thousands of photographs. She freelanced for 18 years as a photographer for the *Washington Post*, American Advancement for Science, Sweet Honey in the Rock, Delta Sigma Theta Sorority, Inc., and Smithsonian Institution. She made headshots for actors and portraits of artists with their work and photographed weddings, bar mitzvahs, and objects for catalogs and for corporation annual reports. She says, "I can do all kinds of photography."[4]

As a photojournalist, her cameras were focused on diverse subjects. She began covering fast-breaking stories and every day events. She says of her career:

The photojournalism path I took had me ready for every kind of person in every kind of situation. I was not flustered because Ricardo Thomas {a White House photographer from an earlier administration} and Roland Freeman {a documentary photographer based in Washington, D.C.} always had either good advice or a word about how to handle a situation. Both of them were clear that the path I followed was my own, not theirs, because I had to pay my dues just like they paid theirs. Musicologist, performer, and scholar Bernice Johnson Reagon would talk about the need to do work correctly with intent. The historical context of being black in America has never left me.[5]

Farmer credits her parents, and her Uncle Junior as major influences in her life. Her uncle used his photographic skills to pay for his studies at Hampton University. Her other mentors include Ricardo Thomas, Roland Freeman, and Roy DeCarava. *The Sweet Flypaper of Life* was also central to her developing a photographic voice. Prior to working on the Kerry/Edwards campaign, she served as Associated Press Photo Assignment Editor, after leaving the position of Director of the White House Photography Office and as a White House photographer during the Clinton Administration.

Sharon Farmer made compassionate and journalistic photographs of President Clinton and his family, his staff and his pets beginning in 1993. Bob McNeely, who was targeted to be Director of White House Photography first hired her. Farmer recalls:

> *He (McNeely) had covered Clinton during the campaign freelancing for* Newsweek *magazine. His wife called me a month after the election saying that her husband wanted to hire me to work as a photographer at the White House. I didn't believe her so I hung up on her because I was trying to finish up a lot of photos that were due to for a client that same day. I thought it was one of my friends playing a joke on me...* [6]

President Clinton described her personal and photographic style at an awards dinner, "We all know that with or without a camera, you're a straight shooter. I can't tell you how much I appreciate that." [7]

Farmer described her access to the President Clinton: "There was down time during the Clinton years where there was time to document the personal side of Clinton. The social occasions, whether we were traveling or not, were not frantic like a campaign is..." [8]

Her eight years experience working with the Clintons introduced her to world events that transformed her life as a photographer:

In 1998, I accompanied the President and Mrs. Clinton to Ghana. There was a huge rally in the stadium in Accra. There must have been over 250,000 people cheering the President and First Lady. They were given the kente cloth of the Africans and, wearing them, proudly stood next to President and Mrs. Rawlings of Ghana. What a moment in time! Never in my wildest dreams did I ever imagine that an American President would visit an African country and be received so wonderfully. That moment, to me, is only second to watching and photographing Nelson Mandela being sworn in as President of South Africa. I attended the event with Mrs. Clinton and the delegation that Vice President Gore led. Every day, I pinch myself to see if I'm dreaming that I have this job here, in this time, in this world.[9]

Sharon Farmer encourages aspiring photographers to "Challenge yourself daily. The more you do, the more you know yourself. Knowing yourself is very important. Never turn down a chance to show what you can do because it's the littlest things that lead to bigger things."[10]

Farmer continues to make well-composed images of her subjects with a sense of understanding the importance of their image and the power of their office. Her visual record of the Clinton Administration's eight years and the Kerry/Edwards campaign offer a historical record of the period and show the significance of the photograph record. Her role as photographer and recorder offer a visual testimony of the complexities of the positions covering a world leader.

Talking Back: Black Women's Visual Liberation Through Photography

...little black girls are not encouraged at home or at school to value their own thoughts. To articulate them is labeled "talking back" and they are even punished. The sense that black females should be supportive or silent is carried over into adulthood. So, like Jane Austen hiding her novel-writing under blotting paper in the family room, black women, too, have been forced to conceal their best contemporary articulations of self under the cloak of fiction....

—Michele Wallace, *Invisibility Blues: From Pop to Theory*

Much attention accorded black female photo artists working in Britain has centered on the works of Joy Gregory, Roshini Kempadoo, and Ingrid Pollard. Though there are many other women actively working in Britain today, I am interested in the works of these three women because their work is concerned with gender-related issues. This select group has repositioned the image of women in British photography as both subjects and image makers, similar to black women photographers in America, such as Lorna Simpson, Clarissa Sligh, Carrie Mae Weems, and Pat Ward Williams. They utilize photography, text, testimony, and memory to structure issues of sex and cultural politics in their work.

By "talking back" and revealing themselves in autobiographical terms, they have made critical visual steps in constructing the ways in which women are viewed in contemporary photography. The dominance of European race-thinking in terms of "Other" is the result of the dominant culture's conscious muting of black women's voices. The power to cause the inactivation of a voice, and thus the diminution of self, is the most destructive psychological weapon used by the larger British culture. Therefore, in simple terms, the dominant culture is the "bully" on the playground. These three artists have collectively ignored the nomenclature of victimization to restructure their own reality in their art, which stands in sharp contrast to the reality of the larger society.

Black female photographers in Britain have found a multifarious yet unified visual voice, absent of formalistic grandstanding. Willing to risk the consequences of talking back to the bully, these artists struggle with a new expressive language, a visual syntax which re-contextualizes old symbolic references. It is a courageous and liberating approach to knowing and learning without dogma or propaganda, which they see as part of a larger political struggle. By re-imaging the lives of black British women, through a hybrid of documentary photography and constructed photographic images, the theme of gender consciousness resonates.

ROSHINI KEMPADOO

Roshini Kempadoo's photographs are an amalgam of photography, text, and reconfigured objects. All of these elements are collected, then presented to draw attention to the exploitation of women at home, in commerce, and industry. In her computer-generated prints from the series *European Currency Unfolds,* Kempadoo acknowledges and publicly claims the vocations of black women through self-portraits and family images. Her constructed images confront the invisibility of female workers in the British economy. Superimposed color images over British currency underscore the exclusion of women in affairs of the state by exposing continued dominance of postcolonial authority in contemporary Britain.

From the series *Sweetness and Light,* 1996
Roshini Kempadoo

Barry Lane of the Arts Council of Great Britain writes:

Roshini's...work is created by means of the new digital technologies and uses the familiar codes and conventions of our popular culture. However, her images powerfully convey fresh meanings and feelings that speak of her personal experiences of family strengths, of travel and up-rooting, and of British racism.[1]

Kempadoo's series, *Presence*, is a critical reading of the black American magazine *Essence*, in that she continues to challenge the [in]visibility of black women:

By centering myself as the black subject visually, it contributes to my constant redefining of the self or selves. Self-articulation still forms an integral part of my work but it is not the only strategy in use here. It links in closely to the wider postmodern notion of identities that seems to be in use with all of the magazines on our shelves at the moment. The 'self' is experienced as more fragmented and incomplete, composed of multiple selves or identities in relation to the different social worlds.[2]

Ironic and suggestive, her visual message about cultural representation retains an optimistic and often humorous sense of realism.

INGRID POLLARD

In the *Big and Little* series, Ingrid Pollard poses her young subjects in the studio and in a homelike setting and photographs them in black and white. Using a landscape environment, Pollard unmasks the notion of stereotypes or social-psychological construct about African Americans. She uses props—things commonly associated with black people including, for example, stalks of sugar cane, a fried chicken box, and a watermelon to question stereotypes. Her pristine landscapes symbolically refer to the work of black people in fields and in kitchens.

Pollard also incorporates Yoruba cosmogenic references such as a

conch shell, which symbolizes the deity Yemaya/Iemenja, identified with the color blue, the ocean, and a seashell; or a young woman behind a yellow candle and squash who pours a libation into the Thames River in honor of Oshun, a Yoruba deity for rivers, love, and wealth. Pollard brings Yoruba cosmology alive. As Kobena Mercer suggests:

Pollard is of a generation {of black British photographers} able to move beyond the protest in order to access the ordinariness of black experiences in Britain, and here she is able to find a wry source of pleasure in the absurdities that often arise when diverse cultures and ethnicities overlap and intertwine in unanticipated ways.[3]

Older subjects positioned in the landscape are a formalist device found in her earlier works, such as *Pastoral Interludes*, in which she explores black identity and dislocation in Britain. She states:

Pastoral Interludes...is a comment on race, representation, and the British landscape...{It} seems to have a lot of resonance for many people. It began as a way of articulating some of the experiences I had in England. It is really a metaphor, a skeleton on which I explored ideas about place, space, and where we all fit in to the world scheme.[4]

The *Big and Little* series might be seen as a direct response to this earlier work. In drawing a parallel between the black-and-white with color, the young boy and girl with the adult woman or man, Pollard creates a dialogue between the present and the future and suggests life might be different for the younger subjects of her photos. As Mercer describes it:

Juxtaposed with images of children, the mawkish sentimentality of the so-called positive image is erased in favor of allowing a more open-ended reflection on the future generations of multicultural England: if our identities were born on the journeys between here and there, then where will they come to be?[5]

JOY GREGORY

Joy Gregory's series *Objects of Beauty* (1993-95), consists of photographs based on developing new paradigms for black beauty. Gregory, as a black woman, critiques this culturally feared subject through self-conscious imagery with straight-forward visual elegance. Her images challenge us to begin this discussion. In *AutoPortrait* (1990), Gregory's self-portraits are free-wheeling and abstract. They are cropped as if frames from a movie still. The gestures are signals for us to "face the mirror." Displacing the conventions of advertising photography, she examines how black subjects are posed in front of the camera. bell hooks has called for "the necessity for black people to decolonize our minds." Relying on the photographic image and the psyche of the black woman as the source for her powerful imagery, Gregory began that process several years ago. She writes:

My interest in ideologies of beauty stem from my past interest in fashion photography and women's magazines. Fashion photography is absent in its call for women to cultivate their independence. This is presented as a contradiction, freedom is laced with notions of beauty resulting in self-hatred, physical obsession, terror of aging, and dread of loss of control. All women must look young and thin. It appears that women are increasingly willing to regard their bodies as photographic images—unpublishable/invisible/shameful until retouched at the hands of a surgeon. People in different societies and different historical periods strive for radically different often completely opposite-cultural ideals. My area of interest is the impact that numerous cultures have had on British concepts of beauty over the last fifty years.[6]

Gregory makes deliberate visual references that encourage the viewer to project some of his/her own emotions onto the work. As Sunil Gupta writes:

> *Gregory is negotiating a delicate path between the political demands of making the Black body visible and desirable as well as subverting the conventions of Beauty as expressed by the fashion industry. Her work finds the slippage in that the same images can be used as both rallying cries for Black women's identity as well as illustrations for magazine work.*[7]

What is most significant about the work of these three women is their strength and diversity. As Jones writes, "Somewhere in the interstices between the much maligned mutability of 'pluralism' and the marginalized trajectory of 'difference' is the common ground where most artists work."[8]

These women photo artists have auto-developed by choosing to "talk back" and, as bell hooks demonstrates:

> *...that initial act of talking back outside the home was empowering. It is that act of speech, of 'talking back'; that is no mere gesture of empty words, that is the expression of our movement from object to subject—the liberated voice.*[9]

AutoPortrait II, 1990
Joy Gregory

244

Visual Testimony: The Photographs of Wendel A. White

As modern visual poets, [black photographers] were…concerned with
locating and reproducing the beauty and fragility of the race, the ironic
humor of everyday life, the dream life of a people.

—Robin D.G. Kelley

American photography began as an art woven from commonplace prosperity
and created an inventory of everyday experience.

—Merry A. Foresta

Wendel A. White strives to capture the "dream life of a people"
through his photographs that offer an alternative reading and analysis of
history. Combining formal portraiture with text, White creates a visual-
ly engaging experience between subject and photographer and collective
memory and cultural practices. The "commonplace prosperity" found in
his works provides a view of America that incorporates the preservation
of life and the survival of a culture. Looking at his photographs of black
towns in New Jersey, I can vividly imagine how these towns served their
inhabitants at the moment of their founding.

White's photographs sparked my interest not just because of their
historical value but also because of my personal memories. As a young
girl, my parents often drove from Philadelphia to Lawnside, New Jersey,
on Sunday afternoons after church services. On Saturday and Sunday, at
least once a month in the winter and two or three times a month in the
summer, we would pile into the car to visit relatives and eat corn on the
cob and barbecue cooked on open pits. I knew then that Lawnside was a
special place, segregated by choice, with everyone enjoying their day off,
telling stories, playing cards or checkers, jumping rope, and sharing in
their community pride. We also often visited relatives in Whitesboro
and Chesilhurst in southern New Jersey. Our family and friends had sec-
ond homes in those areas and were comforted by their isolation and

Trinity A.M.E. Church Gouldtown, New Jersey, 1993
Wendel A. White

sense of communal living. White's photographs speak to the endurance and resilience of these black towns and their inhabitants.

The history of black towns is grounded in community pride and self-governance. More than 50 black towns were established in the United States, four in New Jersey: Lawnside, Gouldtown, Springtown, and Whitesboro as well as some independently incorporated municipalities located in the southern part of the state. They provided opportunities for economic advancement and social uplift and were often seen by their residents as protective havens.

Many of these towns were and are unknown to the larger society, but others have achieved some distinction. They include Boley, Oklahoma; Institute, West Virginia; Mound Bayou, Mississippi; Grambling, Louisiana; Nicodemus, Kansas; and Allensworth, California. Each town had a unique beginning. For example, Allen Allensworth, who was born a slave, founded the first all-black town in California. Lawnside, New Jersey, became the first African American incorporated municipality in 1926. Originally known as Snowhill, it had been established in the latter part of the 18th century and became a stop on the Underground Railroad. Gouldtown derived its name from a black man named Gould who married Elizabeth Fenwick, granddaughter of the English nobleman John Fenwick, a wealthy colonist.

The photographs of these towns are a reconnection with the past, a

remembering of community, individuals, and a legacy bound in pride and pain. Using a contemporary voice, White revisits the towns, some of which are more than 200 years old, photographing the descendants of some of the original townspeople and contextualizing their experiences with words. He explores the connections between slavery and its impact on free blacks, miscegenation, the Underground Railroad, the abolitionist movement, black family life, community history, entrepreneurship, and patriotism.

Born in Newark, New Jersey, in 1956, White received a Bachelor of Fine Arts degree in photography from the School of Visual Arts in New York City and a Master of Fine Arts degree in photography from the University of Texas at Austin. White began this project in the mid-1980s. Like most photographers of this period, he was interested in documenting Americana in the model of the Farm Security Administration photographers.

After moving to southern New Jersey to teach photography, White began taking pictures of his newfound community. Reflecting his interest in the land, White made a series of photographs of the rural and urban New Jersey landscape. His photographs during this period visually analyzed the relationship between the public and private history of black Americans in New Jersey. By focusing on the "the land," White uncovered a lost history of the people in communities in southern Jersey. He writes, "Photography is a way for me to satisfy my curiosity about how things work physically and philosophically."

From its beginning, this project was a self-conscious endeavor. As White explained: "The project is a personal record of my interest in historically African American communities in southern counties of New Jersey. This work is not presented as a historical resource but as an artist's journal of travel and discovery." White looked inside and outside each community, linking enslaved and free blacks of the 19th century to working and middle-class blacks in the 21st century. What is fascinating and engaging about the photographs is the depiction of domestic,

military, political, and economic life through a combination of portraiture, landscape, and the written word. White's photographs form a historical narrative that transcends memory and is informed by his juxtaposition of text and image.

My work uses historical and documentary text combined with images that seek to describe the experience in black communities with this region. The stories of these communities in the southern part of the state are remarkable and generally underrepresented in literature and documentary images.

The visual curiosity that White describes is represented in his first project—photographs of the burial sites of black soldiers who fought in the Civil War. White memorializes the forgotten soldiers by photographing the weatherworn headstones and digitally juxtaposing biographical text about the black men who served in the war. The photographs symbolize the experiences of the black soldiers who believed in freedom and fought for that freedom for black people. They are quiet reminders of the past and, with the current debate on reparations, remind us of the promise of the Civil War and Reconstruction. This subject continued to absorb White as he researched and photographed the desolate sites and collected the related archival records.

White later broadened the project and began photographing descendants of the Civil War soldiers and other families in the area. He also incorporated text into these formal portraits, often placing the photographic images on the left side of the frame and the words on the right. The result is a book-like format that resembles both a 19th century travel album and a personal family album. White serves not only as the image-maker but also the biographer, narrator, and participant. The landscape in which he locates and revives the community's history is transformed into a portable photographic exhibition, growing each time the photographs are displayed.

These symbolic photographs, imbued with communal pride, respect,

and mystery, provoke emotion in the viewer. They encourage us to think about the history of places like Gouldtown and about how the townspeople maintained their close-knit communities. White offers us clues in the photograph entitled *Trinity A.M.E. Church, Gouldtown, New Jersey, 1993*, which depicts a community room with a banner draped over the top indicating the 200th anniversary of the church founded in 1792. Biblical scriptures are written on a chalkboard with the words "Persistant" [sic] and "Prayer" underlined. The image is a simple one— American flag, crucifix, podium, desk and tables—devoid of people, but we feel their presence and their sense of spirituality and community. Lesson plans, photographs, bible verses, and hymnals tell us about Gouldtown's inheritance of endurance.

Photographs of women like Mrs. Tecolia Salters of Chesilhurst, Mrs. Sarah Lucile Stewart-Mitchell of Swedesboro, Dr. Merrie Hill, and Mrs. Elaine Edwards symbolize inherited family and community pride. White contextualizes their individual histories by giving us signifiers within the image and the text. For example, Dr. Hill is seated in her living

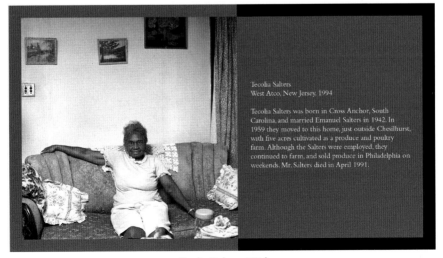

Tecolia Salters
West Atco, New Jersey, 1994

Tecolia Salters was born in Cross Anchor, South Carolina, and married Emanuel Salters in 1942. In 1959 they moved to this home, just outside Chesilhurst, with five acres cultivated as a produce and poultry farm. Although the Salters were employed, they continued to farm, and sold produce in Philadelphia on weekends. Mr. Salters died in April 1991.

Tecolia Salters, 1994
Wendel A. White

room; her demeanor is regal as she looks directly into the camera. Her Persian rug, vinyl covered furniture, mirror, antique table, and silk curtains reveal her status as a middle-class resident of the community. The photographs on the end table memorialize weddings and other family gatherings, but the text tells us her history and that her uncle, Alvin Williams, originally owned the property.

In contrast, the striking portrait of Mrs. Salters is of a woman who has worked the land. This widow is comfortable with the camera and directs her gaze past the photographer to the viewer. She smiles with her eyes as she stretches one arm across the back of the sofa, feeling its texture, and places her other arm next to her body. We see touches of her handicraft in the crocheted doilies and throw pillows on the sofa. Her walls are decorated with small genre scenes. The text enhances the iconography of the portrait by explaining that Mrs. Salters farmed the land that she owned and sold her produce in Philadelphia on the weekends.

The photograph of Mrs. Edwards and Mrs. Stewart-Mitchell is a symbol of community pride and resistance against Jim Crow. The Lodge, its paneled walls filled with photographs and text panels, was once a segregated school and the building is now registered as an historic site.

White's work interprets the history of black towns and explains how personal strife influenced their survival. His photographs portray people as they wish to be seen and are both affirming and challenging. Images of family homes that include views of people's private photographs affirm the subjects' place in history and memory. The text challenges the standard historical record and provides us with access to a world that might easily have been forgotten. The stories White constructs through words and photographs give us a complex history full of charm, irony, pride, and personal revelations.

Endnotes

PICTURING US

1. Monti Nicolas, *Africa Then: Photographs 1840-1918* (New York: Alfred A. Knopf, 1987), p. 73.
2. Sander L. Gilman, "Black Bodies, White Bodies: Toward an Iconography of Female Sexuality in Late Nineteenth-Century Art, Medicine, and Literature" in Henry Louis Gates, Jr., ed., *"Race," Writing, and Difference* (Chicago: University of Chicago Press, 1985), pp. 223-261.

HARMON FOUNDATION

1. Deborah Willis-Thomas, *Black Photographers 1840-1940* (New York: Garland Publishers, Inc., 1985), p.5.
2. Ibid., p.10.
3. William E. Harmon Awards for Distinguished Achievement Among Negroes (New York: Harmon Foundation, 1930).
4. *Negro Artists: An Illustrated Review of Their Achievements* (New York: Harmon Foundation, 1935).
5. Application for William E. Harmon Awards (New York: Harmon Foundation, 1928).
6. Alaine Locke to Harmon Foundation, 1927, letter of recommendation for James L. Allen, candidate for a William E. Harmon Award. Harmon Foundation Papers, Library of Congress, Manuscript Division, Washington, D.C.
7. Carl Van Vechten to Harmon Foundation, 1927, letter of recommendation for James L. Allen, candidate for a William E. Harmon Award. Harmon Foundation Papers, Library of Congress, Manuscript Division, Washington, D.C.
8. Langston Hughes to Harmon Foundation, 1927, letter of recommendation for James L. Allen, candidate for a William E. Harmon Award. Harmon Foundation Papers, Library of Congress, Manuscript Division, Washington, D.C.
9. Langston Hughes to Harmon Foundation, 1928, letter of recommendation for James L. Allen, candidate for a William E. Harmon Award. Harmon Foundation Papers, Library of Congress, Manuscript Division, Washington, D.C.
10. Exhibition of the Work of Negro Artists (New York: Harmon Foundation, 1931).
11. Exhibition of Productions by Negro Artists (New York: Harmon Foundation, 1933), p.7.
12. Alaine Locke to the Harmon Foundation, 1928, letter of recommendation for King Daniel Ganaway, candidate for a William E. Harmon Award. Harmon Foundation Papers, Library of Congress, Manuscript Division, Washington, D.C.
13. Edith M. Lloyd, "This Negro Butler Has Become a Famous Photographer,"

American Magazine (1925), p. (56-58).

14. *The Art of the Negro* (New York: Harmon Foundation and College Art Association, 1934).

15. Unpublished and undated outline of film content, "Negro Artists at Work." Harmon Foundation Papers, Library of Congress, Manuscript Division, Washington, D.C.

16. Ibid.

JP BALL

1. *Ball's Splendid Mammonth Pictorial Tour of the United States Comprising Views of the African Slave Trade; of Northern and Southern Cities; of Cotton and Sugar Plantations; of the Mississippi, Ohio and Susquehanna Rivers, Niagara Falls, & C.* (Cincinnati: Achilles Pugh, Printer, 1855), p. 7.

2. Ibid.: p. 7.

3. Driskell, David C. *Two Centuries of Black American Art* (Los Angeles County Museum of Art, 1976), p. 39.

4. Ibid: p. 39.

5. Rinhart, Floyd and Marion Rinhart. *The American Daguerreotype* (Athens, Georgia: University of Georgia Press, 1981), p. 140.

6. Rochester Frederick Douglass' Paper (April 28, 1854), p. 3.

7. *Cincinnati Daily Enquirer* (November 11, 1854).

8. "Daguerrean Gallery of the West." *Gleason's Pictorial Drawing-Room Companion* (April 1, 1854), p. 208.

9. McElroy, Guy. Essay in *Robert S. Duncanson: A Centennial Exhibition* (Cincinnati Art Museum, March 16-April 30, 1972), p. 11.

10. Billington, Ray Allen (ed.). *The Journal of Charlotte L. Forten* (New York: The Dryden Press, Publishers, 1953), p. 61.

11. Spangenberg, Kristin L. (ed.). Cincinnati Art Museum. *Photographic Treasures from the Cincinnati Art Museum* (Cincinnati: The Museum, 1989).

12. *Seattle Post Intelligencer* (Obituary, July 23, 1923).

13. Williams, George W. *History of the Negro Race in America from 1619 to 1880: Negroes as Slaves, as Soldiers and as Citizens* (New York: G.P. Putnam's Sons, 1883), p. 141.

14. *St. Paul Western Appeal* (March 19, 1887), p. 1.

15. *St. Paul Western Appeal* (July 16, 1887), p. 4.

GORDON PARKS

1. Gordon Parks, *Half Past Autumn; A Retrospective*, (Boston: Bulfich Press Book, 1997).
2. Parks, *Voices ill the Mirror: All Autobiography* (New York: Doubleday, 1990), p. 66.
3. Ibid., p. 74.
4. Cedric Dover, *American Negro Aft* (New York: New York Graphic Society, 1960), p. 49.
5. Parks, *A Choice of Weapons* (New York: Perennial Library, Harper and Row, 1973), p. 171.
6. Parks, *Voices ill the Mirror*, p. 74.
7. Ibid.
8. Ibid, p. 75.
9. Ibid.
10. Parks, *A Choice of Weapons*, p. 172.
11. Parks, *Voices Ill the Mirror*, p. 78.
12. Ibid., p. 79.
13. Howard Chapnick, *Truth Needs No Ally: Inside Photojournalism* (Columbia: University of Missouri, 1994), p. 135.
14. Nicholas Natanson. *The Black Image in the New Deal: The Politics of the FSA Photography*, 1992, p. 266.

TEENIE HARRIS

1. "Priceless Pictures" by Tim Ziaukas, Pittsburgh, November 1993, p. 50.
2. Camara Dia Holloway, *Portraiture and the Harlem Renaissance: The Photographs of James L. Allen*, (New Haven: Yale Art Gallery, 1999), p. 35.
3. "A Place in the Pantheon" by Linda Benedict-Jones, *Spirit of a Community: The Photographs of Charles "Teenie' Harris*, (Greensburg, PA: Westmoreland Museum of American Art, 2001), p. 15.

EXPOSURE

1. Myrlie Evers-Williams, ed. *Steven Kasher's The Civil Rights Movement: A Photographic History, 1954-68*, (New York: Abbeville Press Publishers, 1996), p.7.
2. Sondra Kathryn Wilson, ed., *The Crisis Reader*, (New York: The Modern Library, "Criteria of Negro Art", 2000), p. 323.
3. Daylanne English, "W. E. B. DuBois's Family Crisis in American Literature" Vol. 72, No. 2, June 2000, p.300.
4. Shane White and Graham White in *Stylin' African American Expressive Culture from Its beginnings to the Zoot Suit*, (Ithaca: Cornell University Press, 1998), p. 195.
5. "Our Baby Pictures," Crisis, Brenda Wilkinson, *The Civil Rights Movement: An Illustrated History*, (New York: Crescent Books, 1997), p. 84.
6. Brenda Wilkinson, *The Civil Rights Movement: An Illustrated History*, (New York: Crescent Books, 1997), p.60.
7. Brooks Johnson, ed., *Pictures Tell the Story: Ernest C. Withers Reflections in History*, (Norfolk, Virginia: Chrysler Museum of Art, 2000), p. 60.
8. Ibid, 60.
9. Danny Lyon, *Memories of the Southern Civil Rights Movement*, (Center for Documentary Studies, Duke University, The University of North Carolina Press, Chapel Hill, 1992).
10. Quoted in Aldon Morris, *The Origins of the Civil Rights Movement: Black Communities Organizing for Change*, (New York: Free Press, 1984), p. 106, p. 30.
11. James Turner in *Malcolm X: The Great Photographs* ed. By Howard Chapnick and Thulani Davis, (New York: Stewart, Tabori and Chang, 1992), p. 83.

EMPOWERING THE POWERFUL

1. Bob McNeeley, Director of White House Photography, 1993-1998. January 18, 2001. http://www/kodak.com/us/en/corp/magazine/transcripts/1-18-2001.1-5.shmtl
2. Videotape Remarks to the White House News Photographers' Association Dinner. (President Bill Clinton) (Transcript).
3. Press release, HISTORIC PHOTOGRAPHIC EXHIBIT DEBUTS AT TRUMAN PRESIDENTIAL MUSEUM & LIBRARY. White House Renovation photos featured in New Display. http://www.trumanlibrary.org/news/abbierow.htm
4. Interview with Farmer. Wednesday, July 21, 2004.
5. Interview with Farmer. Wednesday, July 21, 2004.
6. Interview with Farmer. Wednesday, July 21, 2004.
7. Ibid, videotape remarks.
8. Ibid.
9. Yesterday and Today: Behind the Scenes with the President's Staff, Inside the White House, Fall 1999, http://clinton3.nara.gov/wtt/kids/inside/html/fall99/html/intro.html.
10. Ibid. Yesterday and Today: Behind the Scenes with the President's Staff.

TALKING BACK

1. Barry Lane, *ICI Awards* (Bradford, West Yorkshire: National Museum of Photography; Film & Television 1992), p. 26.
2. Roshini Kempadoo, quoted in *ICI Awards*, p. 26.
3. Kobena Mercer, "Home From Home: Portraits from Place in Between:" in *Self Evident* (London: Ikon Gallery in collaboration with Autograph, The Association of Black Photographers, 1995), p. 6.
4. Ingrid Pollard, quoted in *Ingrid Pollard: Monograph* (London: Autograph, The Association of Black Photographers, 1995), p. 6.
5. Mercer, "Home from Home," p. 6.
6. Joy Gregory, quoted in an undated and unpublished grant proposal statement.
7. Sunil Gupta, "Beauty and the Beast: The Work of Joy Gregory" in *Joy Gregory: Monograph*, London: (Autograph, 1995).
8. Kellie Jones, "Re-Creations," *Ten.8* 2, no.3 (Spring 1992), p. 96.
9. bell hooks, *Talking Back: Thinking Feminists Thinking Black* (Boston: South End Press, 1989), p. 9.

The essays in this book have appeared previously, in slightly different form, in the following publications:

"Visualizing Memory: A Photographic Study"
American Art, Issue 17 (1)/2003

"Picturing Us: African American Identity in Photography"
Picturing Us: African American Identity in Photography, Deborah Willis, Ed., (New Press, 1994)

"Women's Stories/Women's Photographies"
Reframings: New American Feminist Photographies, Diane Neumaier, Ed., (Temple University Press, 1994)

"The Harmon Foundation and Photography"
Against the Odds: The Harmon Foundation Gary Reynolds, Barry Wright, Eds. (Newark Museum and the Luce Foundation, 1988)

"J.P. Ball: Daguerrean and Studio Photographer"
J. P. Ball: Daguerrean and Studio Photographer, Deborah Willis, Ed., (Garland Publishing, Inc., 1993)

"Gordon Parks and the Image of the Capital City"
Visual Journal: Harlem and D.C. in the Thirties and Forties, Deborah Willis, Jane Lusaka, Eds (1996)

"Charles 'Teenie' Harris: Portraits of the Hill"
One Shot Harris: Photographs of Charles "Teenie" Harris, Stanley Crouch, (Abrams, 2002)

"Exposure: Civil Rights Photography"
Only Skin Deep: Changing Visions of the American Self, Coco Fusco, Brian Wallis, Eds. (International Center of Photography/Abrams, 2003)

"Empowering the Powerful: Photography and the Presidency"
The Crisis, September/October 2004

"Talking Back: Black Women's Visual Liberation Through Photography"
Transforming the Crown: African, Asian, and Caribbean Artists in Britain, 1966-1996, M. Franklin Sirmans, Mora J. Beauchamp-Byrd, Eds., (Caribbean Cultural Center/African Diaspora ,1997)

"Visual Testimony: The Photographs of Wendel A. White"
Small Towns, Black Lives: The Photographs of Wendel A. White, Wendel A. White, (Noyes Museum of Art, 2003)